PERSIAN PAINTING

— *Sheila R. Canby* —

Published for the Trustees of the British Museum
by British Museum Press

FOR JOHN

© 1993 The Trustees of the British Museum

Published by British Museum Press
A division of British Museum Publications Ltd
46 Bloomsbury Street, London WC1B 3QQ

British Library Cataloguing in Publication Data
A catalogue record for this book is available from the British Library

ISBN 0-7141-1459-6

Designed by Grahame Dudley Associates

Phototypeset by Southern Positives and Negatives (SPAN), Lingfield, Surrey

Printed in in Italy by New Interlitho, SpA, Milan

FRONT COVER Style of Sultan Muhammad: 'Rustam sleeping while Rakhsh fights the lion', from a *Shahnameh* of Firdausi. Tabriz, *c*.1515–22 (detail of fig. 49).

FRONTISPIECE 'Bahram Gur and the shepherd who hanged his dog', from a *Khamseh* of Nizami. Tabriz, 1545–50. 18 × 11 cm. Based on an illustration to Shah Tahmasp's *Khamseh* of Nizami of 1539–43, this drawing depicts the dénouement of the story of a sheepdog who fell in love with a wolf. When the shepherd discovered that the besotted dog had allowed the wolf to steal his sheep, he hanged the dog for its infidelity.

Contents

ACKNOWLEDGEMENTS

The paintings discussed and illustrated in this book come primarily from the British Museum and the British Library. Such rich holdings have few lacunae, but those that exist have mostly been filled by illustrations of paintings in other British collections. I should like to thank my colleagues Muhammad Isa Waley and Jerry Losty of the Oriental and India Office Collections at the British Library, also the Royal Asiatic Society and the British collectors Nasser David Khalili, E. Bahari and Edmund de Unger, for kindly allowing me to publish works in their collections. I am also grateful for permission to reproduce paintings from the Morgan Library, New York, and the Freer Gallery of Art, Smithsonian Institution, Washington, DC.

I am extremely grateful to B.W. Robinson for reading the type-script of this book and making comments that have saved me a great deal of embarrassment. In the few instances where I have not taken his advice, I stand ready to be criticised. Many thanks also to Mrs Lay Leng Goh of the Department of Oriental Antiquities for typing the manuscript, Teresa Francis of British Museum Press for editing it, the British Museum Photographic Service, especially John Williams and David Gowers, for taking the photographs of British Museum and Keir Collection objects, and John Voss for moral support.

Note Because of the general nature of this book, diacritical marks have been omitted from Persian words.

Unless otherwise stated, works illustrated are from the British Museum collections, and measurements include their marginal rulings but not their borders.

INTRODUCTION

Like a tiny world of eternally blooming flowers, sweet-smelling zephyrs, gentle people and effulgent light, Persian miniature paintings invite one to linger and delight in every detail. At their best, they do not just illustrate a story. Rather, they breathe life into the hills and animals, clouds and trees that populate the scene of the narrative. Later, in the seventeenth century, portraiture took precedence over book illustration and man came to dominate Persian painting. Yet Persian artists of every generation and every style retained their innately Persian understanding of design. By favouring two-dimensionality and compositional harmony, they presented things as they should be, not necessarily as they are. Within these parameters Persian artists over six centuries produced paintings unrivalled in their perfect realisation of an ideal world.

This book briefly documents the history of Persian painting from about 1300 to 1900. While texts mention wall-paintings that predated 1300, and Persian books were probably illustrated well before that time, the bulk of material available for study dates from the fourteenth century and later. The majority of works considered and reproduced here come from manuscripts and albums and are small in scale. However, in the nineteenth century artists who in an earlier era might have illustrated manuscripts turned to painting lacquer objects and large works in oil. Even so, the same questions and criteria concerning style apply, especially since nineteenth-century artists often worked simultaneously in several media.

In order to appreciate a particular art form, one must try to understand how and why it was created. To answer the first question, Chapter 1 is devoted to the materials and methods of

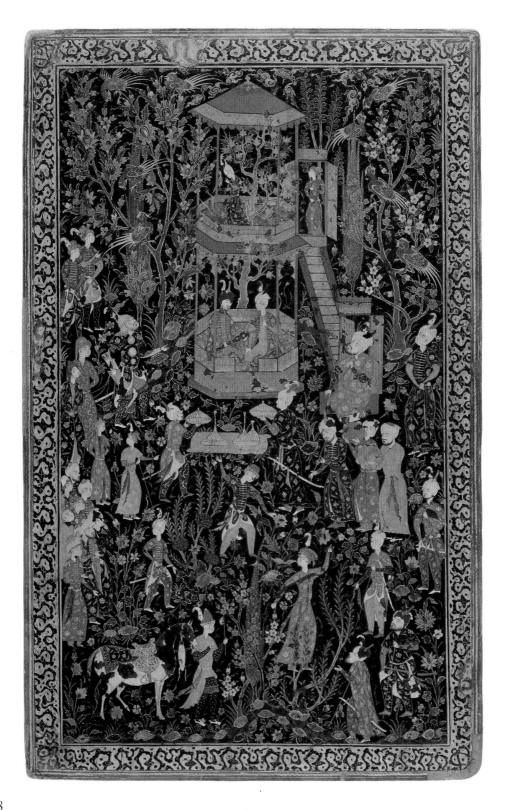

Persian book illustration. Why such paintings were produced is more difficult to pinpoint. Following the birth of the modern Persian language in the ninth century and the versification of its most famous early example, the *Shahnameh* (*Book of Kings*), by the poet Firdausi in 1010, one must assume there would have been an increase in the number of Persian books written. The educated classes in Iran would of course have been literate in the Arabic script because it was the language of their religion, Islam. The Persian language uses the same script as Arabic with a slightly modified alphabet. Although people who wanted to read works such as the *Shahnameh*, the Persian national epic, would naturally have wished to obtain written copies, a different set of circumstances must have led to the manuscripts being illustrated.

First, seventh- to ninth-century frescoes found at Pianjikent in Transoxiana reveal a tradition of wall-painting, already established in the Sasanian period (third to seventh century). The frescoes included episodes from well-known narratives which were probably recited in the very rooms in which they appeared. Thus, the paintings would have served as a visual reference. This type of arrangement could have accustomed people to viewing pictures while hearing, or later reading, a story. Moreover, texts allude to the existence of illustrated manuscripts in Sasanian times. Secondly, a tradition of illustrated manuscripts had existed in the Arab world long before 1300. While many of these were books of a scientific nature, books of fables, histories and other fictional tales were also illustrated.

Although we shall probably never know who first decided to illustrate Persian manuscripts, we can be certain that the idea had taken hold by 1300. Most likely in the beginning illustrations simply supported the narrative and did not include many extraneous details. However, even in the only illustrated Persian manuscript from before the Mongol invasion, a *Varqa and Gulshah*, the decorative possibilities of plants and animals are explored. By the fourteenth century Persian artists were not only embellishing their paintings with extra figures and non-essential accoutrements, but were also, according to recent scholarship, depicting in royal manuscripts episodes that mirrored contemporary situations. Thus, the motivation for illustrating manuscripts quickly advanced beyond producing a simple analogue to the text. The patrons must soon have discovered what the artists already knew: that the experience and enjoyment of looking at a painting, even if it illustrates the written word on the page facing it, stand quite apart from the activity of reading the book. Unlike looking at wall-paintings or large-scale backdrops while someone recites a story,

1 Exterior of a bookcover. Safavid, Tabriz, *c.*1540. Lacquer on leather, 40 × 25 cm. Within an ornate garden pavilion a young prince receives a ceremonial gift of a sword while his courtiers entertain him with music and food.

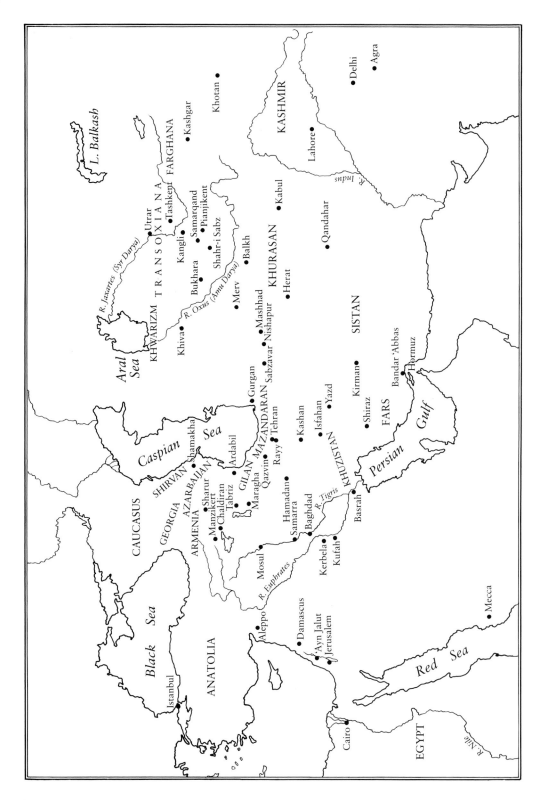

the experience of perusing an illustrated Persian manuscript is an intimate one. Only one or maybe two people can comfortably read the pages and look at the pictures at once. When single-page paintings and drawings began to take precedence over manuscript illustrations, the artists preserved the small size so that they could be included in albums. That small-format paintings should have continued to be produced well into the twentieth century attests to the success of Persian artists in establishing and maintaining an aesthetic that appealed so profoundly to their patrons.

2 Map of the Middle East and Greater Iran.

To a Persian who owned an illustrated *Shahnameh* or an album of paintings and calligraphy, each picture would reverberate with meaning. The story depicted might be so familiar, so well-loved, that looking at it would resemble encountering an old friend. A portrait in an album might not only depict someone known to the owner, but also spark memories of times past, the day and cir-cumstances in which the portrait was painted or drawn. Personal significance such as this can hardly be shared by non-Persian viewers in the twentieth century. Yet one can chart the stylistic development of Persian paintings and place them in their historical context. In so doing, one may perhaps approach an understanding of what Persian artists were seeking to communicate.

The study of Persian painting has been handicapped by a dearth of written sources of the type found in both China and Europe. Scholars strain to identify manuscripts mentioned by the few writers who wrote biographies of painters of their own and earlier eras. Until the late fifteenth century most miniatures were unsigned and unattributed, and after that time the identities of artists became public knowledge only gradually through the use of signatures. With the decline of the court patronage system and the growth of commerce in art, the names of artists functioned increasingly like brand names. This phenomenon led to a number of false signatures being placed on works in the style of well-known artists. Nonethe-less, the great respect accorded to older masters also resulted in emulators copying or adapting their works. This repetition or adaptation of compositions is one of the many threads that connects early Persian painting with its later manifestations.

No matter what its period, a great Persian painting will exhibit a distinct sense of design and an understanding of how to arrange colours and forms on a flat surface to form a rhythmic whole. Despite the influence of European art from the seventeenth century onwards, Persian painters do not appear to have been convinced of the desirability of the illusionism that transforms two dimensions into three. Perhaps such visual tricks seemed innately dishonest. Finally, this art of highly developed surface values draws the viewer

in, but does not trespass into his world. Before the nineteenth century the figures in Persian painting almost never look directly at the viewer. Later, when they do, they keep their emotions to themselves. Yet, the most gifted Persian artists could capture their sitters' characters without invading their wall of reserve.

The survey of Persian painting which follows focuses on works from various regions of Iran and outlines the historical events that led to changes in artistic style. Considering the number of times Iran was invaded, and the ethnic and linguistic diversity of the country, one should not be surprised to learn that influences from abroad often played an important role in stylistic development. Nonetheless, most Persian paintings retain distinctive qualities that set them apart from other styles: intense hues, hard and radiant as jewels, precise execution and virtuoso draughtsmanship, akin to the finest Arabic calligraphy. Yet, at the outset Persian painting did not possess these virtues fully formed. Only over time and through the mysterious alchemy of artists, their patrons, foreign influences and the migration of peoples did Persian painting achieve the glories for which it is known and cherished.

The strength of Persian culture and of the distinctive series of tastes that inform its arts shines through Persian painting of all periods. Whether or not one knows every story and the identity of every sitter depicted matters less than the realisation that Persian paintings, though small in size, express in visual form the ethos of their makers and their patrons.

— 1 —

MATERIALS AND TOOLS OF THE PERSIAN ARTIST

Before a Persian painter could begin to work, he needed certain basic materials – paper, paint and brushes. Depending on whether he operated independently or in a royal atelier (*kitab khaneh*), the artist would have had to buy his supplies himself or at least make his own brushes and mix his own paint. Each of his materials played an important role in the appearance and durability of the final product, a miniature painting intended for a manuscript or album (*muraqqaʿ*). Fortunately, Arabic and Persian texts and modern scientific analysis enable us to determine how paper was produced, the sources of Persian painters' brilliant pigments, and what type of hairs were preferred for their brushes.

Legend has it that paper was invented in China in 105 BC. Made of fibres of the mulberry tree, young bamboo shoots and rags, Chinese paper was produced and sold as far west as Turkestan. Nevertheless, the Persians and Arabs do not seem to have been aware of paper until after the Arab victory at Kangli, between Samarkand and Tashkent, in AD 751. As a result of instruction by a Chinese papermaker from Kangli, the first paper factory in the Islamic world was opened at Samarkand, followed by another in Baghdad in 794. The advantages of paper were not lost on the ʿAbbasid caliph, Harun al-Rashid (r. 786–809) and his ministers. Previously, Arabs and Persians had used papyrus, produced exclusively in Egypt, and parchment for books and documents.

3 Paper mould, front and back view. This modern mould, used for making paper by hand, consists of a fine mesh screen tacked to a wooden frame, approx. 80 × 60 cm.

4 OPPOSITE 'Flowers in a jug' (detail of fig. 75), signed by Shafiᶜ ᶜAbbasi and dated [16]70–1. This drawing has been pounced for transfer to another surface, possibly a textile: tiny pin-pricks follow the outline of the flowers. The white watermark at the right indicates the European origin of the paper. Also evident are the wavy horizontal chain lines and the vertical laid lines of the laid paper mould.

Although paper was not immediately adopted everywhere, its use increased steadily during the ninth and tenth centuries. By the year 1000 it was being produced in all the major Islamic cities from Samarkand in the east to Fez (Fas) and Valencia in the west. Samarkand maintained its reputation as the source of the finest paper long after the technology was available elsewhere.

Unlike Chinese paper, Persian paper was invariably made from fibres of flax in the form of linen rags, with hemp fibres added on occasion. After sorting and unravelling the rags and softening them by combing, the papermaker would steep them in lime water, knead the pulp, and bleach it in the sun. Having repeated the process several times, he would wash the pulp in clean water. Next he would pound it in a mortar or grind it between millstones until it was smooth. To form the pulp into paper, the craftsman would dip a mould, consisting of a wooden frame encasing a flexible cover, 3 into a vat of liquid and fibres. As the mould was removed from the container the water would escape, leaving the fibres massed together like felt. In the commonly used laid mould, the cover was made of reeds or, later, grass strips woven together with horsehair. Faintly visible 'laid lines' left on the paper by the reed or grass strips, and 'chain lines' made by the horsehair stitching typify such hand-made paper. Once the paper was dry, it was sized by soaking it in albumen or a starchy solution to fill in and even out the surface.

5 'Sarkhan Beg, the Chamberlain' (detail of fig. 52), signed by Mir Musavvir. Safavid, Tabriz, 1530–40. The facial features and *taj*, or baton, around which this figure's turban is wrapped have been effaced, revealing the underpainting. Young men such as Sarkhan Beg, who served in the royal household, were chosen for their physical beauty and grace and were favourite subjects of court artists.

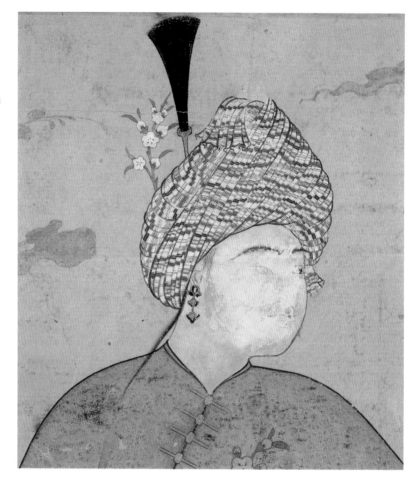

6 Case with brushes and palette. Painted and lacquered papier mâché, 19th century. This box follows the standard form of pencases in use in Iran from the 17th century onward. However, the inclusion of a separate layer containing artist's pigments is highly unusual. Note the individual compartments of red, yellow, blue, black and green paints. Bahari Collection.

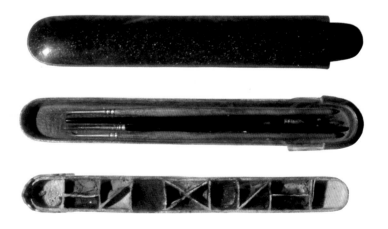

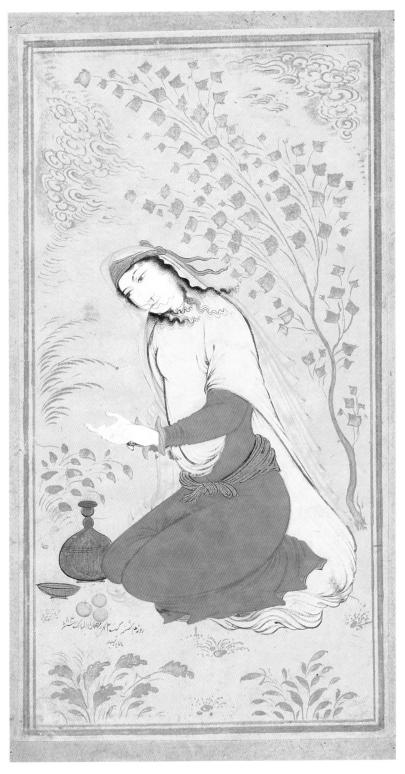

7 'Woman counting on her fingers'. Style of Muʿin Musavvir, dated Wednesday 3rd of Ramazan 1084 AH/ 12 December 1674. 19 × 10.1 cm. Portraits of single figures eating, drinking or performing simple tasks in a landscape setting abounded in 17th-century Persian painting. The composition of this idealised portrait derives from a work by the master Riza-yi ʿAbbasi, completed in the 1620s.

After this the papermaker or the calligrapher or artist would burnish individual sheets with a hard stone, glass or a shell, to strengthen the paper and prepare it for use.

Before applying paint to paper, the miniature painter would have made a preliminary sketch with a fine brush. For details or whole sections of a composition he might borrow from existing works with the help of a pounce. To obtain a pounce he would lay a thin sheet of paper or transparent deerskin over the subject to be copied and prick the outline with a needle. Then, having filled a cloth bag 4 with charcoal powder, he would dust over the pounce, now positioned above his clean sheet of paper. The outline of the original detail was thus transferred to a new page. The artist would proceed with his preliminary drawing, filling in details of costume, physiognomy and landscape. Evidently, he did not paint directly onto the drawn surface. Rather, he lightly coated the surface of the page with sizing, through which his drawing was faintly visible. At this 5 point he was ready to paint.

Persian paintings are rightly admired for the brilliance of their colours, precisely applied to even the most minute details. From a fairly small number of sources Persian painters mixed a dazzling range of hues. The pigments derive from three categories: minerals; 6 inorganic or artificial materials; and organic, that is plant and animal, sources. Amongst the minerals were gold, silver and lapis lazuli, the basis of ultramarine blue, which was pulverised from chunks of stone and washed repeatedly. Likewise, artists could achieve a bright vermilion from ground cinnabar, yellow from orpiment, and green from malachite. Expense and availability of materials and the cost of labour dictated the choice of pigment types, so that substitutes for lapis lazuli, malachite and cinnabar were not uncommon. Instead of lapis lazuli, indigo, a plant derivative, was used for dark blue, and azurite, a copper carbonate destructive to paper, produced a lighter blue. Far more common than malachite was verdigris, a highly corrosive green pigment obtained by dipping copper plates in vinegar and burying them in a pit for a month. Many alternatives to cinnabar red existed. Mercury and sulphur ground and heated together resulted in vermilion, and the bright orange-red of many Persian paintings came from red 7 lead. Despite the dangers of lead-poisoning, red lead and its cousin white lead, made by treating lead with vinegar, enjoyed continuous use from classical times until at least the seventeenth century. Other reds include red-brown iron oxide, carmine from the kermes insect, and some unidentified plant dyes. The universal source of black was carbon, boiled with gall nuts to produce ink.

Unfortunately, some Persian pigments were destructive, and

others tended to change colour or invade their neighbours. Silver, used to depict water, armour and highlights, often tarnishes and turns black. Verdigris eats away not only the paper on which it is painted but also the surrounding pages. White lead and red lead blacken when on their own and turn yellow orpiment to black when they touch it. Azurite also has a corrosive effect. With such dangers it is remarkable that so many Persian miniatures remain intact. Possibly the binding medium for Persian pigments contributed to their durability. Sixteenth-century textual sources seem to indicate that until the 1590s Persian artists used albumen, then glue to bind the particles of pigment. Certainly these binding media contributed to the hard sheen that characterises the surface of early Persian miniatures. Perhaps as the result of European influence, in the late sixteenth century Persian painters adopted gum arabic as a binding medium. While it had a longer shelf life than albumen, gum arabic resulted in thinner, less brilliant surfaces than those found in fourteenth-, fifteenth- and sixteenth-century paintings.

Once the Persian painter had prepared pigments and paper, his final task was to make his brushes. According to Sadiqi Beg, author of a late sixteenth-century treatise entitled *The Canons of Painting*, hairs from a squirrel's tail were the most desirable for painters' brushes. The long hairs of Persian cats also enjoyed favour with artists. Having separated the hairs according to size, the artist would choose only those of exactly the same length. He would tie them together and thread them through a quill, pulling them out at the narrow end. The brushes ranged from extremely fine to thick, enabling the artist to achieve seamless precision in his paintings and a calligraphic, virtuoso line in his drawings.

While individual artists, occasionally with the help of an assistant, designed and executed the actual illustrations in Persian manuscripts, the complete production of an illustrated book could involve many people, all of whom would be employed within the library or book-making atelier of a major, often royal patron. The director of the project would decide which episodes of the narrative should be illustrated. If the borders were to be flecked with gold, specialist gold-sprinklers would perform their task while the paper
9 was still wet. Then, once the sheets were burnished, the scribe would copy the text, leaving space for paintings and illuminations as instructed by the director. The painter or painters would next proceed, followed by the illuminators and gilders, whose intricate decoration adorned the frontispiece, end-page and chapter-headings. These artists were also responsible for ruling and framing the lines that demarcated text from paintings and separated lines of poetry.

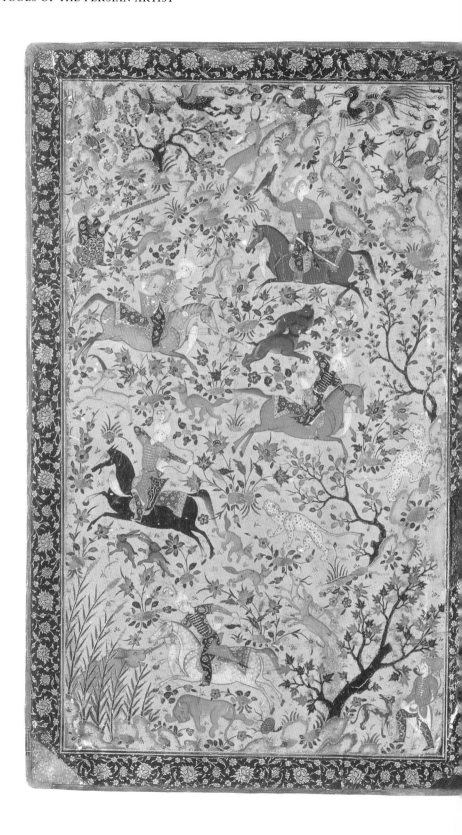

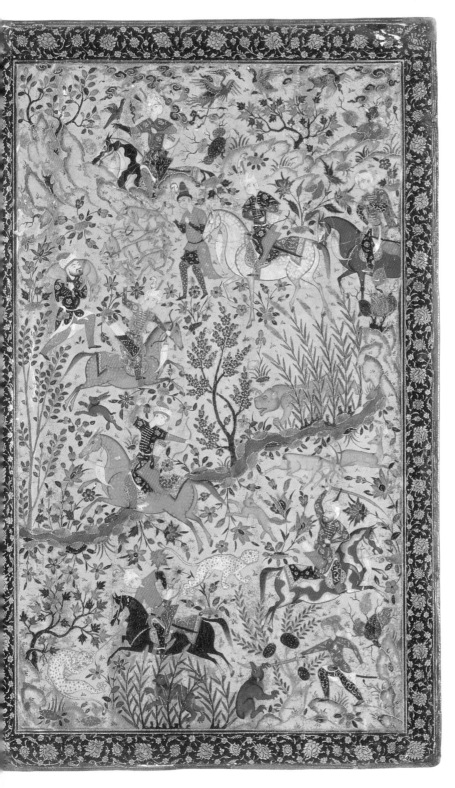

8 Bookbinding. Safavid, Tabriz, *c*.1540. Lacquer on leather, inner sides, each 40 × 25 cm. Unrestrained by the need to illustrate a narrative, the artist of this princely hunt has depicted hunters armed with bows and arrows, swords, falcons and shotguns successfully felling a smorgasbord of prey – lions, bears, cheetahs, deer, rabbits and birds. See also fig. 1 for one of the outer sides.

Once every aspect of the book was complete, it was sewn into a binding. The earliest Islamic bindings consisted of leather covers with stamped and tooled geometric and vegetal ornament and a triangular flap attached to the end cover. In the early fifteenth century Persian bookbinders adopted a new design featuring an oval central medallion with pendants and corner pieces. During the fifteenth and sixteenth centuries the decorative techniques of bookbinders became increasingly complex. Blind tooling on the exterior and a sumptuous combination of cut-out leather, coloured

10

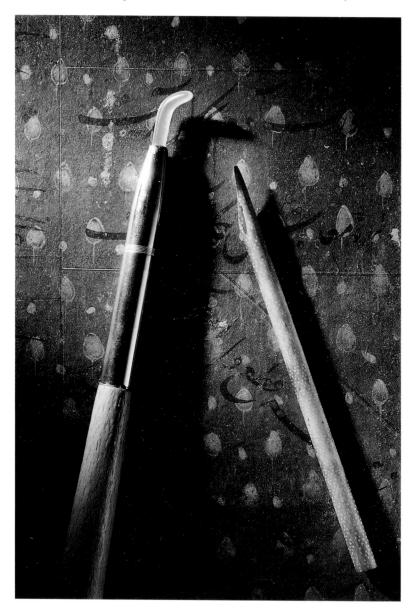

9 Reed pen and burnisher. Iran, 20th century. According to the 16th-century writer Qazi Ahmad, the reed from which a pen was cut should be ruddy-coloured, not too hard or black, or short or long; it should be straight, of medium thickness, not too thick or thin. Burnishers were made in various sizes, long-handled, as here, or with wide grips. Bahari Collection.

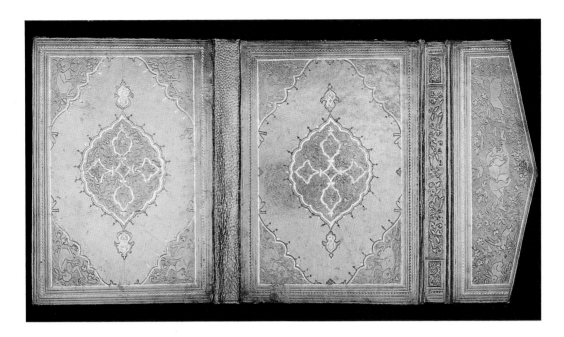

paper and gilding on the interior covers, or doublures, combined to produce highly ornate bookcovers, worthy of the richly coloured, intricately composed miniatures and illuminations to be found within. In the sixteenth century bookbinders added folio-sized scenes of animals and occasionally people in landscape settings to the existing repertoire of vegetal and geometric designs. Moreover, the use of lacquered bindings, which originated in fifteenth-century Herat, increased markedly in the sixteenth century. Safavid lacquer bindings in some cases usurp the imagery of double-page frontis-pieces by presenting a prince and his entourage feasting or enjoying entertainments. Both lacquer and leather bindings continued to be made in the ensuing centuries. However, by the nineteenth century lacquer bindings had won the day. The decorative repertoire now included birds and flowers, scenes borrowed from European paintings, and portraits of historical personages such as the Qajar ruler Fath ʿAli Shah hunting. As in previous eras, the finest bindings accompanied the most expensively produced manuscripts, which were mainly royal commissions.

1, 8

11

Although many of the finest Persian miniatures sprang from the hands and minds of artists working for royal patrons, provincial centres, such as Shiraz, were responsible for large numbers of commercially produced illustrated manuscripts. The range in quality of such non-royal works underscores the importance of the materials, especially pigments, used to produce them. Technically, the best Shiraz paintings meet the standards of Persian court art,

10 Bookbinding. Timurid, 15th century. Leather with gold, tooled and punched, 16 × 31.4 cm (open). In keeping with the expanded decorative repertoire of the 15th century, the maker of this bookbinding has included monkeys in the corners of the covers and a lion attacking a gazelle in a landscape on the flap.

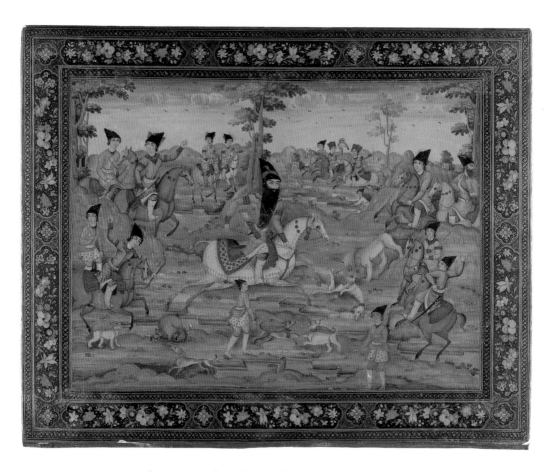

11 Bookbinding. Qajar, early 19th century. Lacquer on pasteboard, 30.2 × 37.7 cm. The dashing Qajar Fath ᶜAli Shah out hunting.

but most often the surfaces of provincial paintings lack its resonance and richness. When the kings and princes of Iran wished to patronise the visual arts, they could and did command the most talented artists and craftsmen, who in turn were provisioned with the finest paper, most brilliant pigments and subtlest brushes imaginable.

— 2 —

THE AGE OF EXPERIMENT

THE 14TH CENTURY

The Ilkhanids

The Mongol invasions in the thirteenth century changed life in Iran radically and permanently. Of the two waves of invasions, the first, led by Chinghiz Khan (Genghiz Khan) in the 1220s, destroyed lives and property in north-eastern Iran on a grand scale. The second, under Hulegu Khan in the 1250s, completed the conquest of Iran and advanced as far as Palestine, where the Mongols were finally defeated by the Mamluks of Egypt at ʿAyn Jalut in 1260. Having sacked Baghdad and executed the ʿAbbasid caliph, Hulegu consolidated his control over Iraq, Iran and much of Anatolia. With his capital at Maragha in north-western Iran, he founded the Ilkhanid kingdom, nominally subject to the Great Khan, Qubilai, ruler of China and Mongolia.

Curiously, despite the extensive physical destruction wrought by the invasions and despite the succession of non-Muslim Mongol rulers, the administrative structure of Iran remained largely unchanged. Ministers and clerics continued to be drawn from the native population. However, their job security (and lives) depended on their willingness to carry out the policies of the Mongols, including several excessively burdensome forms of taxation. By 1295, when Ghazan Khan became Ilkhan, the Iranian economy was in a state of collapse.

Having converted to Islam before becoming Ilkhan, Ghazan

Khan set out to reform the government and revitalise the economy. Taxation was regulated and reduced for those who took up cultivation of new or unused land. Soldiers were paid with the income from land granted to them for farming. The government attempted to improve the postal system, coinage, weights and measures, and the safety of roads. By the time of his death in 1304, Ghazan Khan had curbed the worst excesses of the first seventy years of Mongol rule in Iran. His extremely able minister, Rashid al-Din, who helped spearhead these reforms, continued in office after his death and attempted to maintain the order he had established. Perhaps as a result of the relative calm under Ghazan Khan, Mongol patronage of arts and letters finally took root. As will be discussed further, Rashid al-Din endowed a whole quarter of the Mongol capital, Tabriz, and supported a library *cum* artists' workshop which produced illustrated histories and other texts in the first fifteen years of the fourteenth century.

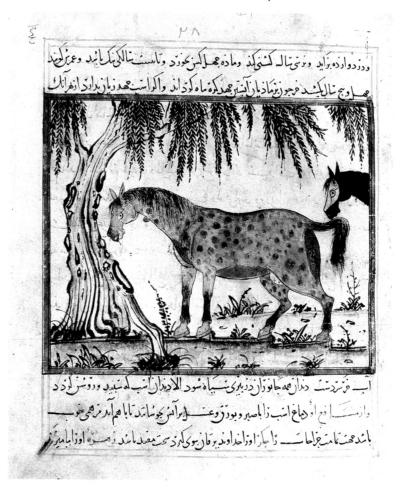

12 'A mare followed by a stallion', from a *Manafi al-Hayawan* (Bestiary) of Abu Sayyid Ubaydallah Ibn Bakhtishu. Maragha, 1297 or 1299. Page 35.2 × 27.2 cm. This illustration accompanies a section on 'Domestic animals and beasts of prey'. The text describes a mare in rut, with tail raised and teats swollen as in the picture, the lifespan and breeding of horses, and the effect of age on horses' teeth. New York, Pierpont Morgan Library.

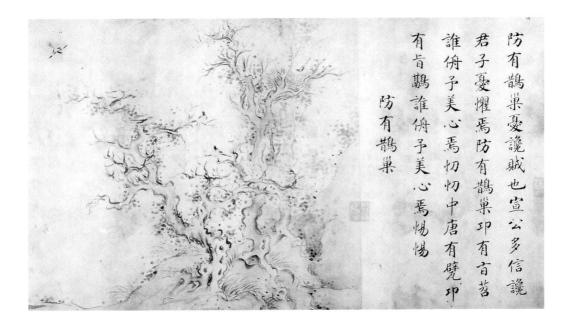

防有鵲巢邛有旨苕誰侜予美心焉惕惕

防有鵲巢

The reign of Uljaytu (1304–16), Ghazan Khan's successor and brother, is less well documented. Apparently he maintained but did not strengthen the administrative infrastructure of Iran. Thus, following his death in 1316, his eleven-year old successor, Abu Saʿid, failed to suppress a power struggle between ministers in which Rashid al-Din met his death and his library and estates were pillaged. Until 1327, when Abu Saʿid finally took full responsibility for ruling the Ilkhanid lands, two Mongol factions, the Chopanids and the Jalayirids, struggled for power. The final eight years of Abu Saʿid's tenure, 1327–35, mark a return to relative stability and good government under the vizierate of Ghiyath al-Din, one of the many sons of Rashid al-Din and, like him, a patron of the arts. Unfortunately, Abu Saʿid left no direct heir. The factionalism that had characterised other periods of weakness in Ilkhanid history reared its head again, but this time no man or group possessed enough strength to seize control of the whole Ilkhanate. As a result, the Jalayirids, Injus and then Muzaffarids dominated the west and south (Iraq, Azarbaijan and Fars), while Sarbadars and Karts prevailed in the north and east (Khurasan) from the 1330s until the invasion of Timur (Tamerlane) in the late fourteenth century.

Although the Mongols were indubitably the major political force in Iran in the thirteenth and early fourteenth centuries, a distinctly Mongol style of painting began to emerge only at the end of the thirteenth century. Possibly the Mongols' enduring nomadism, their status as non-Islamic rulers of a Muslim people or simply their

13 *The Odes of Chen*, section 7 (detail), by Ma Hezhi (*fl. c.*1131–62). China, Southern Sung, 12th century. Handscroll, 26.8 × 731.5 cm. Although Persian painters rarely followed the Chinese example of depicting pure landscape without figures, their respect for Chinese painting is evident both in their borrowing of Chinese motifs and in written references to the excellence of Chinese painting.

smash-and-grab barbarism delayed the development of a fully integrated Mongol style. The manuscript illustrations surviving from the late thirteenth and early fourteenth centuries suggest disparate traditions and influences – Persian, Arab and Chinese – at best loosely united in a single school. Ultimately, these artistic threads were woven more tightly into a recognisable style, which reached maturity on the eve of the demise of the Ilkhanate. Yet, concurrently, provincial schools of painting existed which relied to a greater or lesser extent on the court style of the Mongols.

One of the earliest manuscripts that can be attributed to artists working in the Mongol court is a *Bestiary* (*Manafi al-Hayawan*) of Ibn Bakhtishu, produced in 1297 or 1299 at Maragha, one of the principal Mongol cities in north-west Iran. This manuscript is based on a translation into Persian made at the behest of Ghazan Khan. The work of several hands, including some nineteenth-century tamperers, the manuscript's ninety-four illustrations combine elements of thirteenth-century Arab book painting, Persian ceramic art and the new influence of Chinese brush painting. In 'A mare followed by a stallion' the artist has painted the tree trunk 12 with expressionistic strokes, washes and blots of ink, akin to

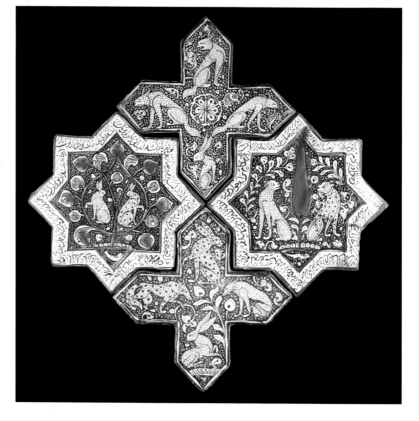

14 Two cross tiles and two star tiles. Kashan, *c*.1260–70. Ceramic, frit body with opaque white and turquoise glaze and lustre over-glaze, diam. of each approx. 20 cm. These tiles are very similar to a group from the Imamzadeh Ja'far shrine at Damghan, made in 1266–7. The inclusion of figural motifs in a religious setting is quite unusual and may indicate that the tiles were salvaged from a palace and reused.

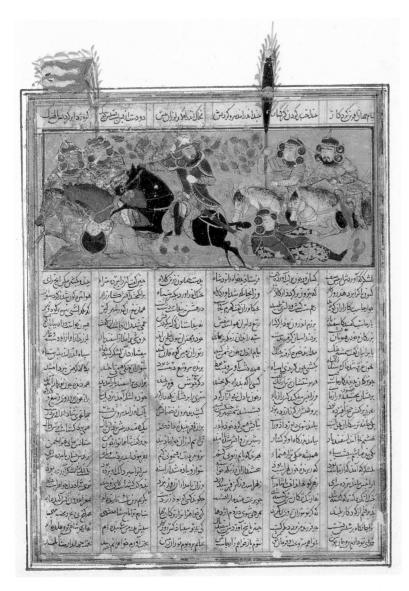

15 'Isfandiyar unhorses Gurgsar', from the 'Second Small *Shahnameh*' of Firdausi. Iran, early 14th century. 19.5 × 13.2 cm (including painted section beyond marginal rulings). Freed from imprisonment, the Iranian prince Isfandiyar joined his father in battle against the Turanians (Turks). Although wounded with an arrow by the Turanian Gurgsar, Isfandiyar lassoed him, pulled him to the ground and dragged him to captivity.

13 Chinese painting of the Southern Sung period (1127–1279). The dappled mare, on the other hand, recalls thirteenth-century Arab renderings of animals whose rumps and bellies are painted in gold in contrast to the rest of their bodies. Twelfth- and thirteenth-
14 century makers of Persian lustreware ceramics also favoured decorative spots on animals of all sorts. While the mélange of styles evident in the *Bestiary* points to a formative stage in the Mongol school of painting, the large size, generous number of illustrations, rich palette and sympathetic portrayal of animals all underscore the high, presumably royal, level of the patronage of this book.

29

Concurrently with the production of manuscripts overseen by the Ilkhan's own libraries, books continued to be illustrated in Mongol provincial centres and for non-royal patrons in major Mongol cities. A group of three small illustrated manuscripts of the *Shahnameh* exemplifies the difficulties of assigning Ilkhanid painting to a specific city or date. These have variously been attributed to Shiraz, Isfahan, western India and Baghdad and dated from 1300 to 1340. The painting shown here, 'Isfandiyar unhorses Gurgsar', 15 reveals far less Chinese influence than the Maragha *Bestiary*, and its tiny scale might suggest that it was not a royal commission. However, the emphasis on action, with the protagonist and his soldiers bounding on horseback across the minimal landscape, is characteristically Mongol. Despite archaic elements, such as the gold sky and floating vegetation, the extension of banners and horses' hooves into the margins anticipates the high Mongol style of the 1330s. While round saddle flaps and rich gold brocaded textiles are found in Mongol miniatures well into the fourteenth century, the distinctive round ear-flaps of the helmets seem to be more specifically of the late thirteenth or early fourteenth century.

Although the small *Shahnamehs* may prove to have had little influence on the Mongol court style of the period 1300–40, they rank high in importance for several other reasons. First, some scholars consider them to be the earliest known *Shahnamehs* to have been illustrated, over 200 years after Firdausi composed the epic. Given the large quantity of *Shahnameh* verses and the recurrence of certain illustrations on thirteenth-century Iranian ceramics, it is safe to say that the epic was illustrated in some, if not all, media before 1300. The inclusion of illustrations may suggest that the patron did not know the book by heart or was not easily able to attend *Shahnameh* recitations. Possibly he led the type of nomadic life associated with the Ilkhans, who moved between encampments almost constantly. The small size and portability of the manuscripts would have suited such a patron. Second, despite their minute size, the facial features and other details are delineated with extreme care. The willingness to miniaturise the illustrations and to depict faces, clothing and animals in careful detail anticipates the great Jalayirid school of painting at Baghdad of the late fourteenth and early fifteenth centuries, but has little to do stylistically with late thirteenth- and early fourteenth-century Baghdad painting. In a period which has left few manuscripts with securely known dates and places of production, the small *Shahnamehs* still tantalise, but their dramatic illustrations of battles and domestic scenes also provide an intimate vision of life in late Ilkhanid times.

The understanding of Mongol and Ilkhanid history has been immeasurably enhanced by the work of Rashid al-Din. A physician by training, Rashid al-Din was commissioned by Ghazan Khan to write a continuation of Juvayni's history of the Mongol tribes and conquests. This history was completed in 1307, three years after Ghazan's death. His successor Uljaytu ordered Rashid al-Din to prepare a history of the world, known as the *Jamiᶜ al-Tavarikh*, or *Collection of Chronicles*. In the suburb he built in Tabriz, the Rabᶜ-i Rashidi, Rashid al-Din employed an international collection of scholars, scribes, bookbinders and painters to compile the four volumes of his history. Each year the workshop was expected to complete one Arabic and one Persian copy of the manuscript, which were then to be sent to the major cities of the Ilkhanid empire. Although over twenty illustrated copies of the *Jamiᶜ al-Tavarikh* must have been produced during the lifetimes of Rashid al-Din and Uljaytu, only two fragments remain. One, in the Edinburgh University Library, dates from 1306–7; the other, in the Nasser D. Khalili Collection, London, is datable to 1314.

Despite the seven-year difference between the two surviving sections of the *Jamiᶜ al-Tavarikh*, the illustrations reveal a unity of style which characterised Mongol court painting under the patronage of Rashid al-Din and Uljaytu. Except for the portraits of Chinese emperors, the format of the illustrations is consistently horizontal, either reaching across the full width of the written page or placed in the centre of the page with text on either side. As in the *Bestiary*, the sky in most of the *Jamiᶜ* pages is unpainted; hillocks or mountains are drawn sketchily and given definition by feathery green strokes denoting blades of grass. The palette of the *Jamiᶜ* illustrations is distinctive. In addition to the predominant warm cream colour of the paper itself, the artists have used silver liberally for highlights of drapery and faces. Originally, this silver must have shimmered quite effectively, but it has tarnished over the centuries and is much darker now than was intended. Otherwise, the colours in the *Jamiᶜ* paintings are quite subdued. Green, orange, blue and red prevail, but saturated colours are used sparingly for garment linings or other accents. Typically, horses and men are long-legged with proportionally small heads.

In the best *Jamiᶜ* illustrations the setting, either landscape or architecture, echoes the figures' poses and accentuates the dramatic content of the scene. Thus, in 'Shakyamuni (Buddha) offers fruit to the Devil', the two trees at the left curve expressively to contain the sycophantic devil with his overlarge outstretched hands. Likewise, Sakyamuni's head fits neatly between the branches of two trees. Scholars have often noted the strong Chinese influence in the *Jamiᶜ*

16

16 'Shakyamuni (Buddha) offers fruit to the Devil', from the *Jamiʿ al-Tavarikh* of Rashid al-Din. Tabriz, 1314. Page 43.6 × 29.1 cm. In the team of scholars gathered by Rashid al-Din to help compile his history of the world, Kamalashri, a Kashmiri Buddhist monk, provided the information about the life of the Buddha. The fruit the Buddha hands to the Devil came from the offerings he received at the end of his long fast. The Nasser D. Khalili Collection of Islamic Art.

al-Tavarikh paintings; the horizontal format recalls Chinese handscrolls, the muted palette and painterly brushstrokes resemble those of Chinese ink painting, and the expressive treatment of natural forms relates to Chinese landscape painting. However, the large scale of the figures and their placement close to the picture plane have far more in common with native Persian painting than with any foreign influence. While the artists of Rashid al-Din's scriptorium were certainly familiar with Chinese, Central Asian, European and Arab works, they forged a style that drew on foreign sources but remained distinct from them. Although the style did not prevail for long, the *Jamiʿ al-Tavarikh* manuscripts of 1306–7 and 1314 do represent a conscious effort to produce a new genre. This paved the way for the final glorious Ilkhanid synthesis and the subsequent development of the classical style of Persian painting.

Although it is one of the passages most often quoted with reference to Persian painting, Dust Muhammad's preface to the album of paintings and calligraphy that he compiled in 1544 for the Persian prince Bahram Mirza (1517–49) nonetheless bears repeating here. Having noted the excellence of portraiture in China and Europe, Dust Muhammad went on to state that, in the reign of the Ilkhanid Abu Saʿid, 'Master Ahmad Musa, who was his father's

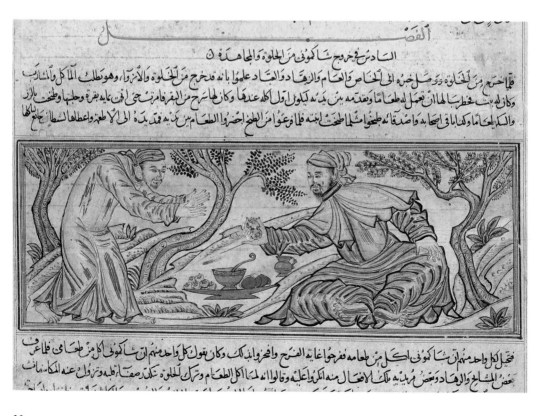

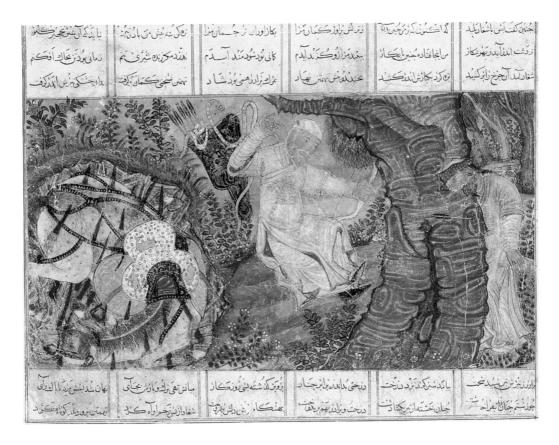

pupil, lifted the veil from the face of depiction, and the (style of) depiction that is now current was invented by him' (Thackston, p. 345). Of the manuscripts attributed by Dust Muhammad to Ahmad Musa, a *Kalilah wa Dimnah* and a *Mi'rajnameh* have been identified by some scholars with two that remain in fragmentary form in albums in Istanbul. Although Dust Muhammad also mentioned a *Shahnameh*, he maintained that it was square in format and produced by one of Ahmad Musa's students, Shamsuddin, not for the Mongols but for the Jalayirid ruler Shaykh Uways (r. 1356–74). It would be convenient to identify the Shamsuddin manuscript with the best-known Mongol manuscript the 'Demotte' *Shahnameh* (so-called after the art dealer who dismantled the manuscript and sold its miniatures individually). However, the style and content of the Demotte *Shahnameh* strongly suggest that it is earlier in date. Despite the fact that Dust Muhammad does not refer to this manuscript, it is thought to have remained in the Persian royal library until its acquisition by Demotte.

The Demotte *Shahnameh* has received almost universal acclaim for the emotional intensity, eclectic style, artistic mastery and

17 'The dying Rustam slaying Shaghad', from the 'Demotte' *Shahnameh* of Firdausi. Tabriz, *c.*1335. Page 40.7 × 29.6 cm. Rustam's envious half-brother Shaghad set a trap – a pit filled with spikes and camouflaged with turf – and then hid behind a tree to await the hero's death. Here, Rustam's horse, Rakhsh, lies impaled, while Rustam fires one last arrow, piercing the tree and killing his murderer.

18 'Dimnah the jackal and Shanzabeh the ox' (above) and 'Shanzabeh the ox with the lion-king', from a *Kalilah wa Dimnah* of Nasr Allah. Shiraz, 1333. Page 29.5 × 18.5 cm. In the kingdom of the lion lived two jackals, Kalilah and Dimnah. Having become the lion's confidant, Dimnah set out to find the source of a strange noise, which turned out to be the bellowing of the ox, Shanzabeh. Dimnah then befriended Shanzabeh and brought him to the lion's court, where Shanzabeh soon replaced Dimnah as the lion's favourite.

grandeur of its illustrations. The lack of a date and artist's or patron's name to associate with such an important manuscript has led to unending scholarly debate about its place in history. Nonetheless, it is most likely to have been commissioned at the end of the reign of Abu Saʿid (1317–35). Very possibly, the moving force behind the project was Abu Saʿid's minister Ghiyath al-Din, who revived many of the scholarly and artistic activities of the Rashidiyya quarter of Tabriz in the 1330s. In the Demotte *Shahnameh* the unusual choice of scenes, in which scheming women figure, imperial legitimacy is emphasised and people are shown in mourning, has suggested a desire on the part of the patron to connect episodes in the *Shahnameh* with current events in the Ilkhanid realm. Certainly the grandeur of the miniatures and the pathos they express reflects the moment of the Ilkhanids' greatest self-awareness and imminent collapse.

Stylistically 'The dying Rustam slaying Shaghad' demonstrates 17 the increased complexity of book illustration from the time of the *Jamiʿ al-Tavarikh* until the 1330s. Where the artist of the earlier painting (fig. 16) left the sky and a large section of the ground bare, here the whole surface has been painted. As in the earlier painting, the curve of the great tree in the foreground encloses the protagonist, in this case Rustam. It also echoes the body of the dying horse, Rakhsh, who lies impaled in a pit of spikes at the left. Despite the many flowering plants in the landscape, the dark tree is devoid of foliage, a gloomy metaphor for the triple murder depicted here. Perhaps to accentuate the sombre mood of this episode, the artist has used a subdued palette. However, many of the other Demotte *Shahnameh* pages contain rich reds, blues, greens and gold. Unlike the *Jamiʿ al-Tavarikh* paintings and some archaising Demotte pages, the figures here are muscular and substantial. Chinese influence is still evident in the Demotte *Shahnameh*, mostly in the rendering of trees and mountains, but it is nowhere as pervasive as in the *Jamiʿ al-Tavarikh*. Produced on the verge of a chaotic period of Iranian history, the Demotte *Shahnameh* none-theless contains in embryonic form the characteristic elements of Persian painting of the fourteenth to sixteenth centuries: highly organised, complicated compositions; brilliant colours; mastery of line and sharp contours; and the ability to convey human emotion through gesture, glance and pose.

The Injus
Often in medieval Iranian history regional governors, appointed by whichever sultan dominated the country, consolidated their power locally to the extent of forming their own semi-autonomous

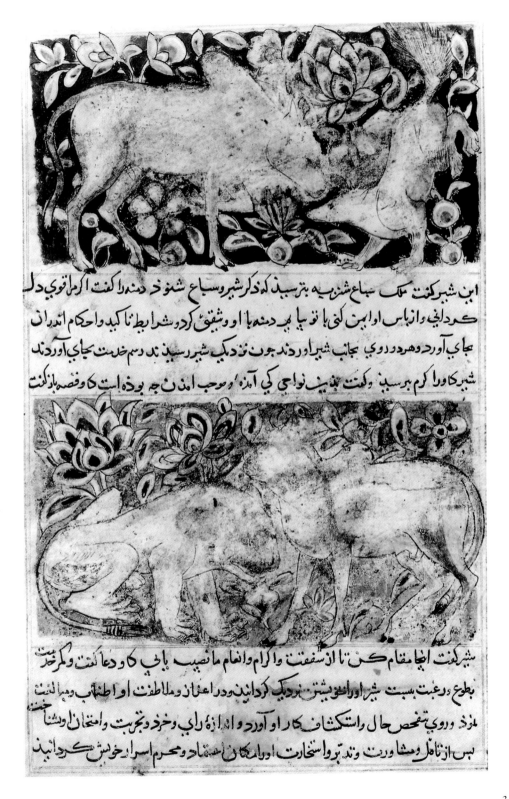

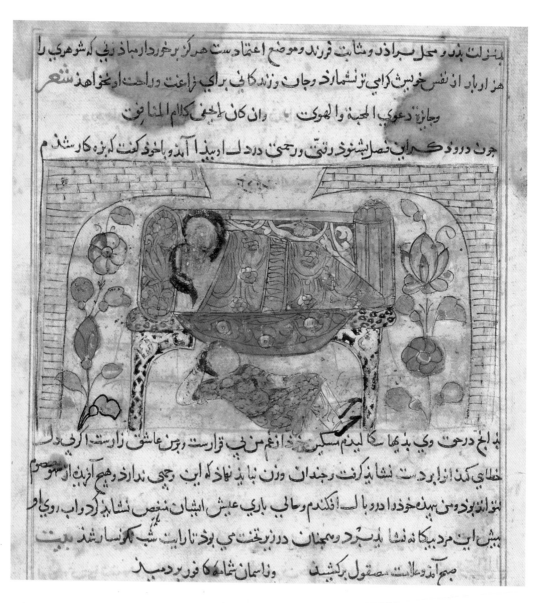

بزرگ بذروحمل برادراذ و مثابت فرزند و موضع اعتماد ست هرکزبرخورداربا ذربی که شوهری را
هزاوباراذنفس خویش کرای تزنشماردو رجان ورزندکاین برای زراعت وراحت او بخواهذشعر
وجازبی دعوی المحبة والهوک ، وان کان اللخنی کلام المنافق
جون درود که دان نصل بشوخ رفتی ورجمن درد لا برسیدا ربید آمدو باخود کنت کبزه کارسشذم

بذابح درحت وی بذها سک لینم مسکین زدانغم من جی قوارست وبرن عاشق زارست اکریذل
خطای کذانابردست نشا یذکرت رجدان وزن نبا یذنهادکه این وجی نداردو حم آزین ازسوص
بنواذبرودمن بهن خودذا ادرو با لا انکدم وحالی باری عیش ابشان منصص نشا یذکردواب روی او
بیش این مردبکا نه نشا لیسبرد رمهجنان در زیر نخنی بو ذتا رایت شب کونسارشذ بیت
صبح آند و علا استه صقول برکشیف و راسمان ثناکها نور بردسبذ

19 'The carpenter of Sarandib, his unfaithful wife and her lover', from a *Kalilah wa Dimna* of Nasr Allah. Shiraz, 1333. Page 29.1 × 18.5 cm. The unfaithful wife spied her husband's foot under the bed and cleverly convinced him of her innocence.

dynasties. One such dynasty ruled in Fars, the south-western region of Iran, from about 1303 to 1357. Called Inju after the term for royal estates distributed by the Mongols, this dynasty governed from Shiraz and patronised an active school of provincial painting. Two pages from a dispersed manuscript of a *Kalilah wa Dimnah* of 1333 18, 19 typify the style of this school in the second quarter of the fourteenth century. The format of the book is large, though not nearly as grand and carefully laid out as the Demotte *Shahnameh*. The charm of the manuscript illustrations lies in the lively use of colour – the bright yellow, blue and red backgrounds seen here, the sketchy, extremely

free use of pen and brush, and the outsized, unnatural flowers filling most available spaces. Despite being roughly contemporary with the Demotte *Shahnameh*, this manuscript owes very little to the Mongol court style. Chinese influence is entirely absent; compositions are far from complex; and nature in no way reflects or augments the narrative content of the illustrations. In addition to the rather slapdash rendering of plants, animals, people and architecture, the paint itself, especially the red, appears to have been of sub-royal quality. Possibly the source of the red was a fugitive vegetable pigment rather than the more permanent and expensive vermilion.

The differences between a *Shahnameh* of 1341, commissioned by Qiwam al-Dawla wa'l-Din, a vizier of the Inju ruler, and the earlier *Kalilah wa Dimnah* may have less to do with stylistic development than with subject-matter. As 'Rustam shooting Ashkabus and his horse' reveals, the same careless brushwork prevails here. However, at least the hillock on which the horse writhes and the trees that rise from it indicate a desire to define the landscape. The faces and poses express movement and emotion, though possibly those in the *Kalilah wa Dimnah* would, too, if they had not been rubbed out by iconoclasts. The fairly liberal use of gold hardly achieves the same effect as in the Demotte *Shahnameh*, again because the artist appears not to have known the royal recipe and certainly had not

20

20 'Rustam shooting Ashkabus and his horse', from a *Shahnameh* of Firdausi. Shiraz, 1341. Page 28.9 × 24.4 cm. Upon seeing his fellow Iranian Ruhham defeated in combat by Ashkabus the Kashani, Rustam challenged Ashkabus to do battle on foot. First Rustam taunted Ashkabus, then felled his horse with one arrow, and finally shot a fatal arrow at the warrior's heart.

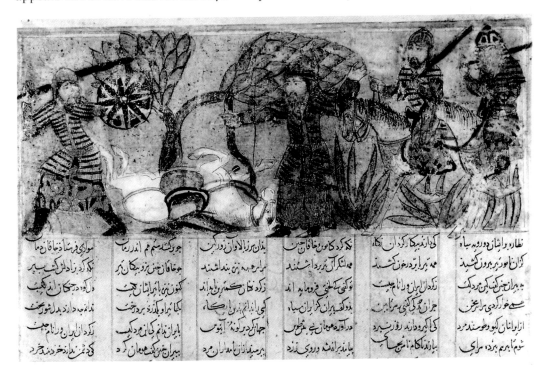

21 'Khusrau watching Shirin bathing', from a partial *Khamseh* of Nizami. Muzaffarid, Shiraz, late 14th century. Page 25.5 × 16 cm. After the Persian prince Khusrau was told in a dream he would have a beautiful princess named Shirin as his love, he sent his friend Shapur to find her in Armenia. Upon seeing Khusrau's portrait, Shirin, in turn, fell in love with him and departed for Persia. On her journey she stopped to bathe in a pool. There Khusrau spied her, but quickly she dressed and rode off towards Persia. Keir Collection.

submitted to the rigours of training in the royal atelier. Despite the provincial quality of the *Kalilah wa Dimnah* and the 1341 *Shahnameh*, they show the independence and vitality of the artists of Shiraz and introduce a school of painting which survived the vicissitudes of Iranian patronage up to the seventeenth century. Much as the Chinese produced ceramics of one style and level of quality for imperial use and of another style and quality for export, so in Iran royal manuscripts were produced at court while Shiraz artists illustrated books for less exalted local clients and for export to India and Turkey. The influence of Shiraz painting in these countries in most cases outweighs its intrinsic merit, but demonstrates the power of novelty and the persuasiveness of Persian style at all levels.

The Muzaffarids

While the mature Ilkhanid style of the Demotte *Shahnameh* continued and developed after the collapse of the Mongols, the Inju style disappeared with the fall of the dynasty to the Muzaffarids in 1353. Led by Mubariz al-Din Muhammad ibn Muzaffar, the Muzaffarids also took Isfahan (1356) and briefly held Tabriz in 1359. Although their sojourn in Tabriz may have resulted in manuscripts or artists who had once worked for the Ilkhanids coming to the attention of Mubariz al-Din, the Muzaffarid style of painting owes a greater debt to the contemporary style of Jalayirid painting. Unfortunately, the earliest known Muzaffarid manuscripts date from the 1370s, so one cannot be certain how the style developed in the 1350s and 1360s.

A painting of 'Khusrau watching Shirin bathing' reveals several 21 characteristics of the Muzaffarid style, despite areas of damage and repainting. First, it displays the high horizons and rounded hillocks before a brilliant deep blue sky consistently favoured by Muzaffarid artists. Often, as in this painting, rocks are indicated at the horizon line by parallel strokes of gold or grey in contrast to the ground colour. The distinctive Muzaffarid turban, somewhat rubbed in this painting, consists of a large *kula*, or central cap, and a bulge of cloth on one side of the head with a narrow trailing fringe spilling out from the folds. Horses often have small heads in proportion to their bodies, whereas human heads are disproportionately large. The faces in Muzaffarid paintings tend to be perfectly 22 ovoid in shape with tiny mouths, small bright eyes and spiky horizontal moustaches, but such moustaches had apparently gone out of style by the 1390s. Unlike Shiraz painting of the 1330s and 1340s, Muzaffarid illustrations contain much natural detail. Tufts of grass, flowers and trees inhabited by birds abound. The best

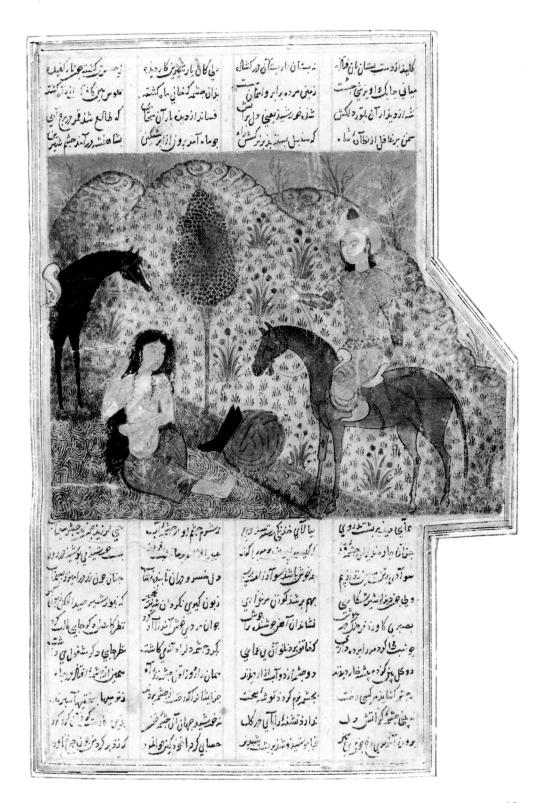

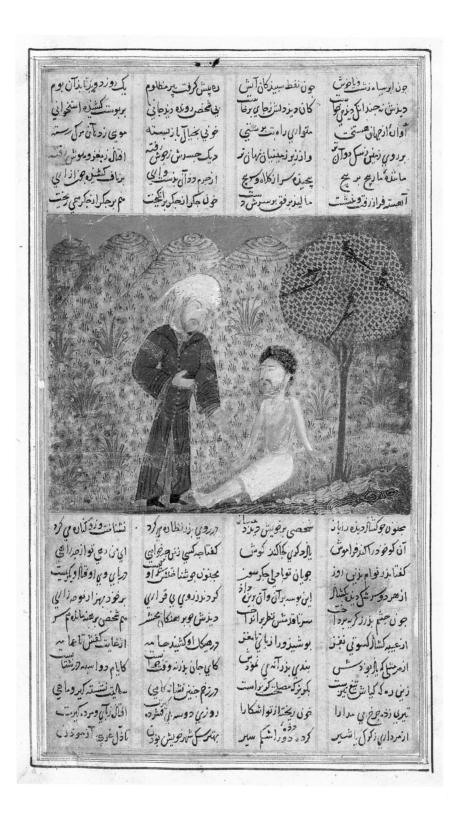

paintings of the school reveal a remarkable use of sinuous line and the decorative abstraction of natural forms, which set these works apart not only from the earlier Inju paintings, but also from the contemporary Jalayirid school.

The Jalayirids

When the Ilkhanid Abu Sa'id died in 1335 without a direct heir, various viziers and regional governors put forth their chosen candidates to succeed him. Inevitably the factions fought amongst themselves for primacy, but no one pretender was strong enough to gain control of all the Ilkhanid lands. Thus, like the Injus and the Muzaffarids their successors, the Jalayirids, who governed Anatolia (Rum) for the Ilkhanids, capitalised on the confusion to consolidate their power. By 1339 the Jalayirid leader Hasan-i Buzurg had secured control of Baghdad and tried unsuccessfully to seize Tabriz. Upon Hasan-i Buzurg's death in 1356, his son, Uways, succeeded him, and by 1360 he was master of Tabriz.

What happened to the artists of Tabriz in the two tumultuous decades between the death of Abu Sa'id and the advent of Uways has long puzzled scholars. The sixteenth-century writer Dust Muhammad stressed the chain of tutelage from Ahmad Musa, artist at the court of Abu Sa'id, to Shamsuddin, 'trained in the time of Sultan Uways' (Thackston, p. 345). No mention is made of artists working for Hasan-i Buzurg, or for any of the claimants to the Ilkhanid throne. Either Shamsuddin worked in Baghdad or he began to work for Uways only after 1360 when the Jalayirids took Tabriz. Although very few, if any, works can be safely attributed to Tabriz in the period between 1336 and 1356, a limited number of detached paintings mounted in albums now in Istanbul and Berlin can tentatively be placed in the 1360s and 1370s. The style of these miniatures depends to a large extent on the high Ilkhanid idiom of the Demotte *Shahnameh*. However, the interior scenes reveal a more developed sense of spatial recession, reinforced by the slightly smaller scale of the figures in relation to their surroundings. Furthermore, the palette has become even richer and is used to heighten the contrast between adjacent areas of pattern. Although these paintings lack the emotional pitch of the Demotte *Shahnameh*, nature continues to play a sympathetic role, echoing the mood of outdoor scenes. In one remarkable manuscript of the third quarter of the fourteenth century, the Istanbul University Library *Kalilah wa Dimnah*, the artist has extended the illustrations into the margins, defining these as a corollary space to the site of the main action. By the mid-1370s, when Uways died, the canon of Persian manuscript painting for the next two centuries was set. Refine-

22 'Majnun visited by his father', from a partial *Khamseh* of Nizami. Muzaffarid, Shiraz, late 14th century. Page 25.5 × 16 cm. As a schoolboy the Arab Qays fell obsessively in love with Layla, the daughter of the leader of another tribe. When Layla's father learned of this infatuation, he forbade Qays to see her. Qays, by now dubbed 'Majnun' or madman, fled to the desert. Here his father tries to dissuade him from his passion, but to no avail. Keir Collection.

23 'Khusrau comes to Shirin's castle', from a *Khamseh* of Nizami. Jalayirid, Baghdad, 1386 and 1388. Page 18.5 × 12.4 cm. Towards the end of the story of their star-crossed lives, Khusrau finally came to claim Shirin for himself. As he approached on a path covered with carpets and embroidered cloths, Shirin's attendants scattered gold coins before him, while Shirin herself watched first from the roof and then from her chamber. British Library.

ments and variations continued, but artists and their patrons had found the balance between abstraction and naturalism, colour and line, nature and man that best represented the Iranian psyche. Despite invasions, conquests and changes of capital, this classical Persian idiom played on like a melody to which all improvisations and variations ultimately referred.

For eight years after Uways' death, from 1372 to 1384, his son, his brother and leaders of the Qaraqoyunlu (Black Sheep) Turkmans fought to lead the Jalayirids. Finally, Uways' brother, Ahmad, prevailed, taking control of Azarbaijan and Iraq, including Tabriz and Baghdad. By 1386 Ahmad's holdings were threatened by Timur (Tamerlane), who seized Tabriz and appointed his son as governor. Although Timur certainly carried off some craftsmen to Samarkand, other gifted artists must have gone to Baghdad with Ahmad Jalayir. There 'Abd al-Hayy, the pupil of Shamsuddin, continued to work for Ahmad until he, too, was abducted by Timur's army of occupation, presumably in 1393, the date of Timur's first seizure of Baghdad. Again Ahmad was forced to flee, this time to the Mamluk courts at Damascus and then Cairo. Following his sojourn with the Mamluks, Ahmad re-established himself in Baghdad in 1394, but in 1401 Timur returned and inflicted severe damage on the city and its inhabitants. As before, Ahmad found safe haven in Egypt. The death of Timur in 1405 enabled Ahmad to make Baghdad his capital for a third time. By 1406 he had regained possession of Tabriz, where he remained until 1410, when he died defending the city against the Qaraqoyunlu Turkmans.

As a patron, Ahmad Jalayir employed the leading artists of his day, and in turn one of them, 'Abd al-Hayy, taught him to draw. The earliest illustrated manuscript from his reign contains two dates, 1386 and 1388. Not only is it the earliest known illustrated version of the *Khamseh* of Nizami, but also, despite being of sub-royal quality, it embodies the style of painting perfected slightly later by the best of Ahmad's artists. In 'Khusrau comes to Shirin's 23 castle' the earlier flirtation with extending the illustration into the margin (fig. 15) has progressed to a full-blown marriage of text, illustration and margins. Now the left-hand margin, upper margin and adjacent column of text incorporate Shirin's castle, while the garden is contained between the right-hand margin and text above and below. The Jalayirid artist has maintained the high horizons of his predecessors, but now the figures are more slender and elongated. The Chinese influence on vegetation has given way to regularly placed tufts of grass and flowers, and the dramatically twisting trees have become tame-looking.

Ahmad Jalayir, a poet in his own right, must have encouraged

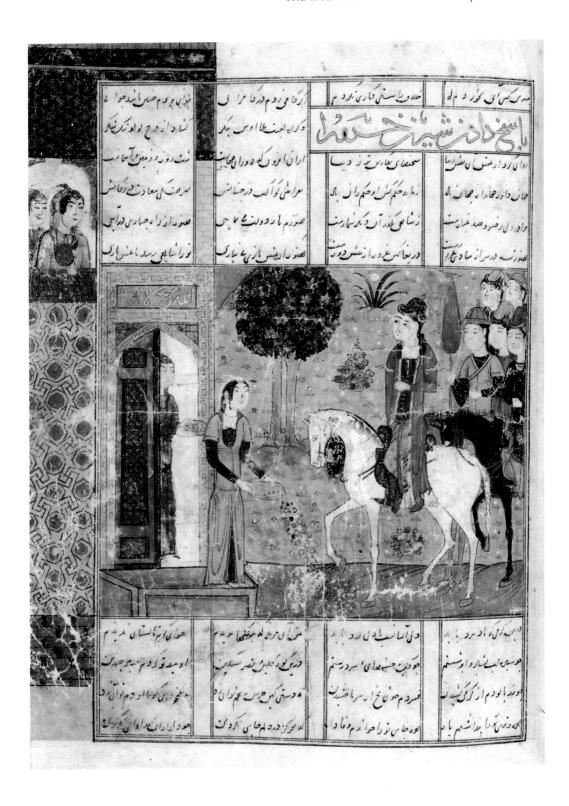

24 'Princess Humayun spies Humay at the gate', from a manuscript of *Three Poems* of Khwaju Kirmani. Jalayirid, Baghdad, 1396. Page 38.1 × 24.7 cm. The Persian prince Humay dreamed of the beautiful Chinese princess Humayun and set out to find her. Here he is shown arriving at her castle gate. British Library.

lyricism, both visual and literary, for only under his guidance did poetical and mystical writings begin to be illustrated. With the *Three Poems* of Khwaju Kirmani the lyrical possibilities of Persian painting attained a new level. According to the colophon, the first half of the manuscript was completed at Baghdad by the scribe Mir ʿAli b. Ilyas of Tabriz in March 1396. Additionally, the painting of 'Humayun enthroned on the day after her wedding' (fol. 45b) contains the signature of the artist Junayd, mentioned by Dust Muhammad as a pupil of Shamsuddin, the leading artist at the court of Uways. Not only is this the earliest recorded signed Persian miniature, but this illustration and the eight others in the manuscript represent a quantum leap in the development of Jalayirid painting. As is evident in fig. 24, the composition and myriad meticulously rendered details serve to reinforce the mood and meaning of the story. From the balcony of an apparently hexagonal tiled tower with elaborate grille-work and wooden openwork window screens, the princess Humayun spies Humay at the gate. The high, though flimsy-looking, wall outside her garden in no way hinders Humay from returning the gaze of his beloved. Various other devices, such as the rows of darting birds and Humayun's brilliant red dress draw one's attention to her. The promise of love and beauty is poignantly expressed by the verdant garden, with its abundance of flowering plants and trees, in contrast to the more subdued landscape outside the walls. While symbolism in Persian painting is almost never specific in the way that one would expect of fourteenth-century Italian or Netherlandish art, certainly here nature and architecture are used to reinforce the subject and emphasise its meaning. By using the whole page, reducing the scale of the figures and placing them back from the picture plane, Junayd has produced a complex and intricate *mise en scene*, the prototype for some of the most beloved paintings of the Timurid and Safavid periods.

Different classes of texts have traditionally required different styles of illustration. Thus, while epics such as the *Shahnameh* abounded with combats and enthronement scenes and the poetry of Nizami or Khwaju Kirmani tended to have more static, lyrical miniatures, the illustrations of scientific texts relied on the compositions and diagrams of the twelfth- and thirteenth-century Arabic treatises from which the later Persian and Arabic versions ultimately derived. For this reason the illustrations to an astrological manuscript, presumably produced at Baghdad under the Jalayirids around 1400, contrast strikingly with the *Three Poems* of Khwaju Kirmani. Although the manuscript, written in Arabic, may not have been intended for Sultan Ahmad Jalayir himself, the large

25

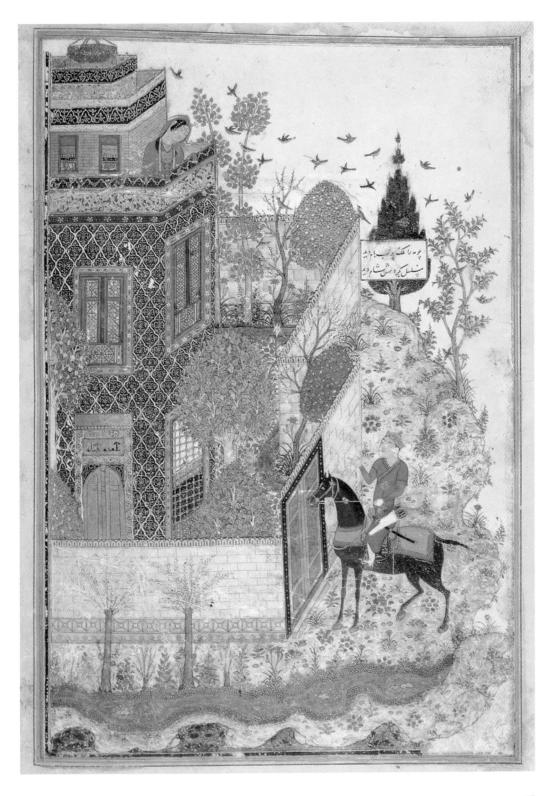

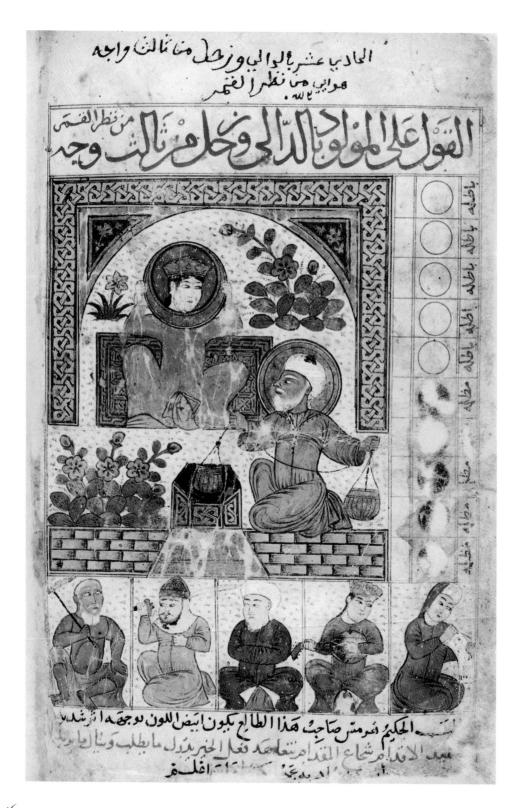

25 PREVIOUS PAGE, LEFT
'The House of the
Moon', from the *Kitab
al-Mawalid* of Abu
Maʿshar in an
astrological manuscript.
Jalayarid, Baghdad, late
14th century. Page 26 ×
18 cm. The illustrations
to this section of the
manuscript follow a set
pattern in which the
sign of the zodiac, its
planetary lord and its
decan (ten days of
planetary influence) are
shown above five
figures, or Terms. The
illustration is entitled
'The discourse on him
who is born under the
sign of Aquarius [the
well] and Saturn [the
white-bearded, kneeling
man] in the third decan
under the influence of
the moon [seated
woman with crescent
moon]'. Keir
Collection.

26 PREVIOUS PAGE, RIGHT
'The valley of the
quest', from the *Divan*
of Sultan Ahmad
Jalayir. Jalayirid,
Tabriz, c.1406–10. Page
29.2 × 20.3 cm. The
marginal drawings in
this manuscript most
likely represent six of
the seven valleys
described in the Sufi
mystical poem *The
Language of the Birds*
by Farid al-Din ʿAttar.
The first valley is
shown here.
Washington, DC, Freer
Gallery of Art.

flowers, regular tufts of grass and architectural details conform to Jalayirid norms and differ from Arab scientific painting of the same period in which setting is not implied. In the Jalayirid illustration the artist has included the necessary diagrams for lunar stages and houses to the right and below figures of the moon and the old man Saturn. Yet, the mood of the painting is as anecdotal as it is didactic and represents a rare merging of Iranian and Arab taste.

From 1406 to 1410 Ahmad Jalayir enjoyed a final period in Tabriz. Two manuscripts have been assigned to Jalayirid royal patronage at this period. One, a *Khamseh* of Nizami, relates closely to the *Three Poems* of Khwaju Kirmani, though its scenes are slightly more intimate than those of the earlier manuscript. The other, the *Divan* of Sultan Ahmad Jalayir, in some ways ranks as 26 the more remarkable of the two. Eight of the 300-odd folios in this book of poems, composed by Ahmad Jalayir himself, contain marginal drawings of figures in landscape and angels in swirling clouds. In keeping with the mystical bent of Sultan Ahmad's poems, the drawings have been interpreted as representing the seven stages of attainment of union with God, as described in the poetical treatise *The Language of the Birds* by ʿAttar (died c.1230). Stylistically, the drawings combine an awareness of Chinese brush-painting technique, already in evidence in early and mid-four-teenth-century miniatures, and a more spontaneous version of the figural types found in Jalayirid painting.

For this period the inclusion of drawings, especially such fresh renderings of scenes of daily, rural life, is exceptional, if not unique. While some scholars have attributed the drawings to ʿAbd al-Hayy, another possibility might be considered. In discussing the artists at the court of Sultan Ahmad, Dust Muhammad mentions that ʿAbd al-Hayy instructed the Sultan, who in turn produced an illustration to an *Abu Saʿidnameh* in *qalamsiyahi* (literally, 'black pen', but essentially brush or pen and ink) technique. Would it be too far-fetched to imagine that the marginalia in Sultan Ahmad's *Divan* are the work of the great patron himself? In the end, whoever the artist was, his works flesh out our understanding of the prodigious contribution of the Jalayirid school to Persian painting. With the encouragement of Sultan Ahmad, Jalayirid artists worked in a variety of techniques, created many of the archetypal compositions used by the next five generations of Persian artists, and attained the level of perfection and harmony of colour that set Persian book painting apart from all other styles.

— 3 —

CLASSICISM AND EXUBERANCE

THE 15TH CENTURY

Timur and his successors

One hundred and fifty years after the Mongols had first invaded Iran, Timur and his armies swept in from the north-east, sowing terror and devastation in equal measure across the land. By 1400 Timur had conquered all of Iran, parts of Asia Minor, Iraq, India as far as Delhi, and had advanced in Russia to within 200 miles of Moscow. Even in old age his appetite for conquest was insatiable; when he died in Utrar in 1405 he was on a military expedition with the aim of taking China. In the Middle East, only the lands of the Mamluks, rulers of Egypt and Syria, eluded his grasp.

While Timur modelled many aspects of his military organisation and campaigns on those of the Mongols, his attitude to the arts differed substantially from theirs. Whereas the Mongols began to patronise architecture and the visual arts only after their territorial gains were consolidated, Timur's 'artistic policy' was integral to his political and military aspirations. He would offer the governors of the cities or regions he defeated the opportunity to avoid destruction in exchange for fealty. If the offer was refused, Timur invited his armies to massacre the population, destroy or steal property, and spare only children, the aged and artists and craftsmen. These artisans were then deported to his capital at Samarkand, where they were employed on the massive building projects he commissioned. Additionally, Timur's sons and grand-

sons, who were given governorships in the conquered cities, had access to artists and craftsmen from the capitals of the Muzaffarids. (Shiraz, Isfahan), Jalayirids (Tabriz, Baghdad) and Karts (Herat). The story of Persian painting from the first half of the fifteenth century is that of princely patrons and their artists.

From 1370, when he established his capital at Samarkand, until his death in 1405, Timur spent the majority of his time away from his native region of Transoxiana. Even when he stayed in Shahrisabz, the city nearest his place of birth, or in Samarkand, he lived as often in lavish tents as in his palaces themselves. The remains of buildings Timur commissioned – the Friday Mosque ('Bibi Khanum') and Gur-i Amir mausoleum in Samarkand, and the Aq Saray ('White Palace') in Shahrisabz – embody the grandiose vision of a ruler now thought to have been obsessed with achieving legitimacy in the eyes of his Iranian and Turko-Mongol subjects. Certainly the sheer size and lavish decoration of the buildings announce his power and wealth, yet, oddly, not one illustrated manuscript or mural painting can be firmly attributed to his patronage. Presumably, since Timur spent so much time on military campaigns and accompanied by a full retinue, including artists, he would have had access to illustrated manuscripts. Moreover, certain scholars believe that some of the paintings – especially those depicting Persian princesses with Central Asian demons or guardians – found in albums now in Istanbul must originally have come from Samarkand and could have been royal commissions. Unfortunately, the written documents which would confirm such a theory have not so far come to light, and, since Timur was illiterate, he may have had no interest in books, even illustrated ones.

During most of his life Timur attempted to limit the power and independence of his sons and grandsons by appointing them to governorships of the localities he conquered and assigning non-royal regents to act as their watchdogs. Thus, when Timur died, although he had named his grandson Pir Muhammad b. Jahangir as his successor, the path to the sultanate was by no means clear. Another grandson, Khalil Sultan, challenged Pir Muhammad immediately and proclaimed himself Sultan in Samarkand. Meanwhile, Shah Rukh, Timur's only surviving son, strengthened his position in Khurasan, where he was governor, and extended his hold over Gurgan and Mazandaran (north-central Iran). By 1409 he was ready to take Transoxiana, where he easily defeated Khalil Sultan in Samarkand. Instead of moving his seat of operations to Timur's capital, however, Shah Rukh returned to his own city, Herat, and appointed his son, Ulugh Beg, governor of Samarkand.

Lacking the personal charisma of Timur, Shah Rukh was forced to spend his first decade as Sultan consolidating the central territories of the Timurid realm. While Tabriz and Anatolia were ultimately wrested from the Timurids by the Turkmans in the mid-1430s, Shah Rukh and his sons enjoyed enough stability in Khurasan, Transoxiana and Fars to sponsor a cultural revival on a grand scale. The manuscripts produced for Shah Rukh himself tend to embody his own imperial aspirations, as well as a desire to identify himself and his dynasty more completely with the metropolitan world of Islamic Iran as opposed to the tribal Turko-Mongol traditions of Timur and Central Asia. Yet, because of the accidents of survival, the tale of Timurid painting begins not with Shah Rukh in Herat, but with his nephew Iskandar Sultan in Fars province.

Like most Timurid princes, Iskandar Sultan served as governor of several cities. In the late 1390s he was appointed acting governor of Shiraz; he then held the governorships of Ferghana, Kashgar and Hamadan, finally returning to Shiraz in 1409. Rebellious even during Timur's lifetime, he continued to foment treachery against Shah Rukh and finally brought about his own downfall by laying waste to the city of Kirman. In 1414 Shah Rukh removed him from his governorship in Shiraz and had him blinded, putting an end to

27 'Garshasp demonstrates his prowess as a hunter', from a *Collection of Epics*. Timurid, Shiraz, 1397–8. Page 21.9 × 11.7 cm. Garshasp, an ancestor of Rustam, has seized a stag by the antlers in a show of strength before the evil king Zahhak. The serpent next to Zahhak's head is one of two that sprang up when the devil kissed his shoulders and that required human heads for sustenance. British Library.

28 'Iskandar visits the sage', from a *Miscellany* written for Jalal al-Din Iskandar ibn 'Umar Shaykh. Timurid, Shiraz, 1410–11. Page 18.4 × 12.7 cm. In Persian literature Alexander the Great is known as Iskandar and is considered to be a descendant of the Persian king Darab. Iskandar is portrayed not only as a great conqueror but also as a seeker of immortality; here he comes to question an ancient sage who wore a robe of grass and lived in a cave. British Library.

both his political and artistic career. In 1415 he was put to death.

Long before he met this sorry end, possibly even as an adolescent, Iskandar in Sultan had begun to patronise the arts. A *Collection of Epics*, dated 1397 and presumably copied and illustrated for Iskandar in Shiraz, combines in its miniatures elements associated with the Muzaffarid style of Shiraz, on the one hand, and those of the Jalayirid painters of Baghdad, on the other. Thus, while the pointed moustaches and high horizons recall Muzaffarid painting, the meticulous treatment of geometric and floral ornament stems from the Jalayirid school. The inclusion of gold ornament on a gold ground, a favourite device of Iskandar Sultan's artists working around 1410, may indicate either the patronage of the young Iskandar or that of this brother, Pir Muhammad.

By 1410 Iskandar Sultan's artists were producing an exceptional group of manuscripts in a style in which the promise of the 1397 miniatures was now fully realised and a complete synthesis of the Muzaffarid and Jalayirid styles was achieved. In this period, two *Anthologies*, one from 1410, the other from 1410–11, a horoscope manuscript from 1410–11 and an astronomical manuscript of the same date are known to have been commissioned by Iskandar. The 1410–11 *Miscellany* embodies his taste in manuscripts; on many of the small-scale pages the scribes wrote two texts, one in the centre of the page and one in the margins. Some pages contain marginal drawings and triangular illuminations reminiscent of the *Divan* of Sultan Ahmad Jalayir. Additionally, double-page paintings appear in the body of the manuscript, not just as a frontispiece. Stylistically the manuscript is marked by numerous original compositions executed in harmonious colours on a minute scale. The elongated human bodies and lyrical treatment of nature recall the Jalayirid style, but the gold or starry lapis lazuli skies and organic, coral-like rock formations anticipate the great Timurid manuscript illustrations of the 1430s and 1440s.

Perhaps because Iskandar Sultan's attention turned to architectural commissions in Shiraz around 1412, fewer manuscripts can be assigned to his patronage after 1411. Upon expelling Iskandar Sultan from Shiraz in 1414, Shah Rukh removed his artists and scribes to Herat. Nonetheless, Ibrahim Sultan, Shah Rukh's son and Iskandar Sultan's successor, must have retained some artists, as manuscript production continued at Shiraz and other Fars centres and several manuscripts can be attributed to his patronage. An anthology, dated 1420 and now in the Museum für Islamische Kunst, Berlin–Dahlem, contains a dedication from Ibrahim Sultan to his brother Baysunghur, whom Shah Rukh had sent in the same year to be governor of Tabriz. Most likely the manuscript was a gift

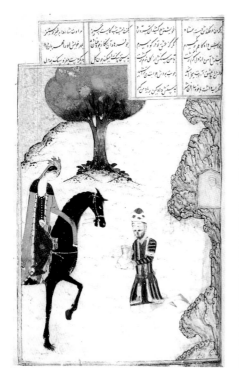

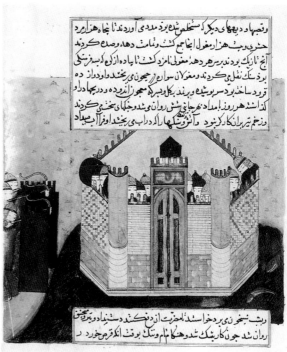

29 ABOVE LEFT 'Shirin visiting Farhad on Mount Bisitun', from a *Khamseh* of Nizami. Timurid, Shiraz, 1435–6. Page 19.7 × 14 cm. To provide Shirin with milk Farhad built a channel from a distant pasture. He also carved her likeness in the rock of Mount Bisitun. British Library.

30 ABOVE RIGHT 'The siege of the fortress of Khujand', from a *Ta'rikh-i Jahan-gusha* of ʿAta Malik ibn Muhammad Juvayni. Timurid, Shiraz, 1438. Page 26.6 × 18.4 cm. In AD 1220, 70,000 Mongols and conscripts besieged the Central Asian city of Khujand.

from Ibrahim to Baysunghur. While the quality and level of modernity vary from miniature to miniature, the illustrations represent a return to some aspects of the late fourteenth-century Shiraz style, especially in the treatment of landscape.

By 1435–6, the date of a *Khamseh* of Nizami, the style associated with Ibrahim Sultan was fully developed. In the illustration of 'Shirin visiting Farhad on Mt Bisitun' the attenuated figures introduced by the Jalayirid artists of Iskandar Sultan have been retained. However, the painter has avoided extending the composition into the margins and has maintained the simplicity of earlier Shiraz painting in which compositions with two or three figures were the norm (see fig. 22). 29

Even before the death of Ibrahim Sultan in 1435, Shiraz artists were producing illustrated manuscripts for non-royal consumption in a style far less refined than that associated with the two greatest patrons of the early fifteenth century, Iskandar Sultan and Baysunghur. In the 'Siege of the fortress of Khujand' the artist has made little effort to adjust the scale of the figures to that of the walls behind which they hide. The lavender and aqua tones used to such advantage in the depiction of rocks in royal manuscripts of this period are here rather strangely employed for the exterior and interior walls of the castle. Although the unruled borders indicate 30

that the illustration was unfinished and the artist perhaps intended to include the sky, the horizon of the picture as it stands is high and typical of Shirazi Timurid painting. Far from meticulous, the rendering here nonetheless communicates the event of the siege in an abbreviated, almost symbolic manner.

Another page from the same manuscript exhibits an equally irrational sense of spatial relationships. Especially odd is the section in which the cypress is covered with a cloud, a flowering tree, the canopy and the carpet, tipped up at an impossible angle. Yet neither did this artist who felt free to overlap elements in this way shrink from using broad passages of strongly contrasting colours with panache. The leafy vegetation covering the ground marks a departure in the Timurid painting of Shiraz and anticipates the Turkman treatment of greenery in the second half of the fifteenth century.

The miniatures from a dispersed *Shahnameh* produced in Shiraz about ten years later show less reliance on Jalayirid forms and a closer kinship with Muzaffarid painting of the late fourteenth century. While the artist still extends the picture into the margin, as in 'Rustam slaying Pilsam in single combat', he has revived the Muzaffarid facial type with its ovoid shape and spiky moustaches. Moreover, the native Shiraz taste for sinuous line and ornamental forms is amply evident in the dragon and jagged spears of 'Isfandiyar slays the dragon'. While the men's physiques in these

31 BELOW LEFT 'Rustam slaying Pilsam in single combat', from a *Shahnameh* of Firdausi. Timurid, Shiraz, *c.*1435–40. Page 19.5 × 14.8 cm. Rustam rode forth in battle, speared the Turanian general Pilsam and flung his corpse into the enemy ranks.

32 BELOW RIGHT 'Isfandiyar slays the dragon', from a *Shahnameh* of Firdausi. Timurid, Shiraz, *c.*1435–40. Page 19.4 × 14.6 cm. In the third of his Seven Stages, or tests, Isfandiyar defeated a fire-breathing dragon by placing a box with swords protruding from all sides on a chariot and climbing inside it.

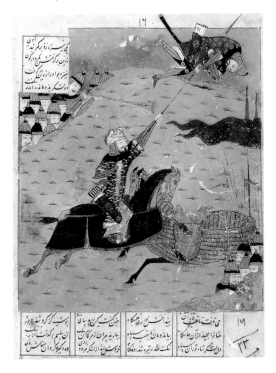

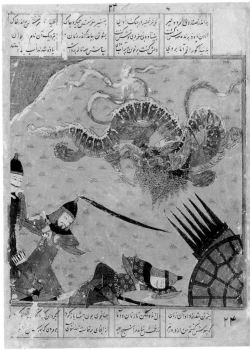

33 'Kuyuk the Great Khan', from a *Ta'rikh-i Jahan-gusha* of ʿAta Malik ibn Muhammad Juvayni. Timurid, Shiraz, 1438. Page 26.5 × 17.2 cm. The third Great Khan of the Mongols and grandson of Chinghiz (Genghis) Khan, Kuyuk ruled from 1246 to 1248. His enthronement took place at his camp near Qaraqorum. After being seated first on a gold throne and then on a felt blanket, Kuyuk received gold, silver, jewels and other gifts from his nobles.

34 OPPOSITE 'The sages of China bringing books on history to Uljaytu', from a *Majmaʿ al-Tavarikh* of Hafiz-i Abru. Timurid, Herat, *c*.1425–30. 33.8 × 23 cm. The Timurid historian Hafiz-i Abru based the section of his *Majmaʿ al-Tavarikh* from which this page comes on Rashid al-Din's *History of the Mongols*, begun under Ghazan Khan (r. 1295–1304) and completed in the reign of Uljaytu (1304–16). Here the Chinese sages Li ta-chih and Maksun present books on history to the Ilkhan, seated under a tree.

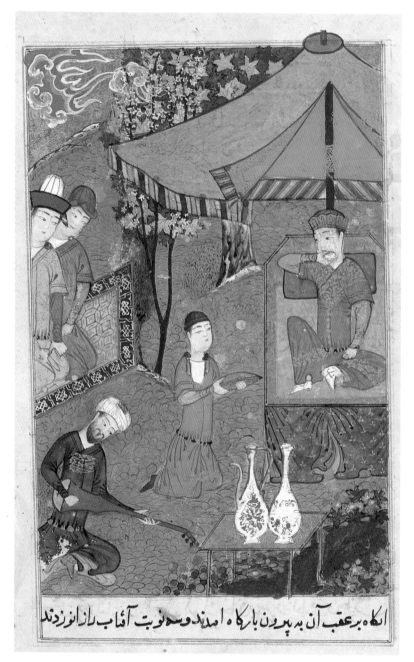

paintings are rather more robust than those in the poetical manuscripts commissioned by Ibrahim Sultan, possibly the bellicose nature of the narrative called for more masculine, muscular figures.

During the years following the demise of Iskandar Sultan, Shah Rukh and his sons Baysunghur and Ulugh Beg employed the most forward-thinking artists in the Timurid realm, most of whom had been deported from Shiraz to Herat by Shah Rukh, or earlier from Tabriz and Baghdad by Timur. Additionally, in 1420 Baysunghur apparently found artists still living in Tabriz who had worked for Sultan Ahmad Jalayir, and he duly brought them to Herat when he returned there in 1421. With such a collection of talent, Shah Rukh and Baysunghur in Herat and Ulugh Beg in Samarkand set about commissioning illustrated manuscripts to suit their own temperaments and tastes.

Shah Rukh (r. 1409–47) not only sought to ensure the supremacy of his own line of descent from Timur, but also aimed to establish order and stability in his empire by the rule of Islamic law. By most accounts an upright and decorous leader, Shah Rukh favoured straightforward illustrations to the historical texts he commissioned. The best known of these, the *Majmaʿ al-Tavarikh* of Hafiz-i Abru, is a continuation of the Mongol *Jamiʿ al-Tavarikh* of Rashid al-Din (see fig. 16). Several copies of this manuscript were illustrated during Hafiz-i Abru's lifetime: one, in Istanbul, is dated 1425 and another, whose pages are widely dispersed, must be roughly contemporary with it. Rendered in a style which Richard Ettinghausen has dubbed 'the historical style of Shah Rukh', paintings such as 'The sages of China bringing books on history to Uljaytu' 34 contrast markedly with contemporary Shiraz work. Both the size of the illustrations and the scale of the figures are large. A pervasive plainness characterises the composition, in which the figures are arranged in a band across the foreground, the pale blue ground undulates across the middle, and the blue sky streaked with red and gold implies infinite distance. Unlike Shiraz painting after 1415, the spatial relationships are clear and rational, and details such as the figures' headdresses and accoutrements serve to make their role understandable. Like the *Jamiʿ al-Tavarikh* of the previous century, Shah Rukh's historical illustrations did not provide the basis for future developments in Persian painting. Perhaps the narrative historical mode smacked too much of real life and contained too little embellishment to suit the tastes of most later patrons or their artists.

By contrast to Shah Rukh's manuscripts, those prepared for his son Baysunghur (1399–1433) represent to many scholars and lovers of Persian art one of the pinnacles of miniature painting. Despite an

addiction to wine which caused his untimely death at the age of 34, Baysunghur succeeded in inspiring the best artists of his day to new heights in the illustration of such well-known books as the *Shah-nameh*, *Kalilah wa Dimnah*, and the *Gulistan* of Saʿdi. Additionally, the artists in Baysunghur's atelier made designs for textiles and leather, wall tiles, metalwork and jewellery. In short, the visual environment of the Timurid realm derived its unity and high level of perfection from one prime source, the royal workshop at Herat.

A bibliophile and calligrapher in his own right, Baysunghur began commissioning books as a youth. By the mid 1420s the crystalline, utterly balanced style of Baysunghuri painting was essentially formulated. Like the manuscripts made for Shah Rukh, those of Baysunghur were mostly large-scale. Yet in the place of bland, predictable compositions, his artists gloried in subtle variations of pose, vegetation and rocks. No one element in a composition outweights another, except the main protagonist, be he the seated prince holding his wine cup or Isfandiyar slashing at a
35 fierce wolf. The geometry and harmony of Baysunghur's pictures often, though not always, rely on the interplay of horizontals and diagonals and the rhythmic repetition of colours at intervals across a page. Unlike the provincial Shiraz artists, who struggled to paint within contours, Baysunghur's painters achieved complete clarity through their meticulous attention to detail and proportion. The quiet, ordered world presented in their work is courtly to its core and must reflect Baysunghur's sophisticated intellectual aspirations, if not the actual fabric of his life. Upon Baysunghur's death in 1433 his atelier was not dispersed, although some artists may have emigrated to centres in Fars, Azarbaijan or even India. Royal patronage continued at Herat, as exemplified by a well-known
36 manuscript of the *Shahnameh* produced in the 1440s for another Timurid prince, Muhammad Juki. While the figures in the Muhammad Juki illustrations are smaller in scale than those in the Baysunghur manuscripts, the precision of execution, preference for compositions constructed on the diagonal, and extraordinary combinations and harmonies of palette all derive from the Baysunghuri precedents. Nonetheless, some of the compositions are strikingly original and the manuscript as a whole is of a very high standard, a fact underscored by the presence of owners' stamps of every Mughal emperor from Babur (r. 1494–1530) to Aurangzeb (r. 1658–1707).

Many of the compositions in Baysunghur's manuscripts served as prototypes or at least points of departure for illustrations of the same stories by artists of succeeding generations. In fact, painting paralleled literature by becoming increasingly self-referential. The

'Isfandiyar slashing at a wolf', from a *Shahnameh* of Firdausi. Timurid, Herat, 1430. Page 38 × 26 cm. In the first of the Seven Stages, or tests, which he underwent on a journey to Turan, Isfandiyar fought two wolves, which he riddled with arrows and then beheaded with his sword. Tehran, Iranian Organization for Cultural Heritage, Gulistan Palace Library.

36 'The battle of Ruhham the paladin and Bazur the sorcerer', from a *Shahnameh* of Firdausi. Timurid, Herat, *c*.1440. 33.4 × 22.2 cm. Much of the *Shahnameh* centres on the age-old enmity between the Turanians and the Iranians. Here Ruhham has found the Turanian sorcerer Bazur, who has sent snow and freezing weather and caused the defeat of the Iranian army. As Bazur wielded his mace, Ruhham cut off his hand with his sword and the climate returned to normal. London, Royal Asiatic Society.

borrowing of vignettes and complete compositions abounded in later Timurid painting and continued into the seventeenth century. While painting flourished under royal Timurid patronage, numerous illustrated books were also produced for non-royal and provincial patrons. A tiny detached page of a hunting scene from a 1427 manuscript of Khwaju Kirmani's *Humay and Humayun* combines the minute scale associatd with Iskandar Sultan's anthologies with distinctively striated rocks unlike those in Shiraz or Herat paintings of the same period. Despite the manuscript having been assigned to Shiraz in the past, the name of the scribe, ʿAli bin Yusuf al-Mashhadi, may indicate that it was prepared at Mashhad or another provincial centre. 38

Detached folios such as 'Courtiers by a stream', the left-hand portion of a painting whose right section is in Boston, are often difficult to situate in time and place. With its high horizon, gold sky and decoratively silhouetted tree, the painting might be assigned to either Shiraz or Sultanate India in the 1440s. The artist has depicted the bearded square-faced men and their slender smooth-faced pages with more care and precision than one encounters in many Shiraz works of the same period, and although the thriving artistic milieu in Shiraz enabled artists of varying levels of expertise to prosper, it is also possible that this is the product of an Indian court school under strong Shiraz influence. 39

An important phenomenon of fifteenth-century Persian painting and design is the profound influence of Chinese ornament. We saw in Chapter 2 that during the Ilkhanid period the format, brushwork and palette of Chinese painting were adopted wholesale in such manuscripts as the *Jamiʿ al-Tavarikh*. By contrast, Timurid artists working at the royal atelier derived innumerable designs for bookcovers, textiles, saddles, metalwork and manuscript borders from Chinese decorative arts such as textiles and ceramics. During the reign of Shah Rukh numerous embassies were exchanged with China, and for a few years around 1420 the Timurids enjoyed excellent trade relations with the Ming Chinese. Even when the Chinese returned to the position of considering all commodities presented by foreigners to be tribute, trade continued. As the century progressed, the Mongols increasingly became middlemen in overland trade, while the Chinese themselves plied the seas between South-East Asia and the Arabian peninsula, using blue and white porcelains as ballast for their ships.

Various works on paper and silk collected in albums in Istanbul and Berlin and dispersed in many public and private collections attest to the strong impact of Chinese painting and ornament on Persian artists of the second quarter of the fifteenth century. A

37 drawing such as 'Two pheasants in a landscape' features Chinese motifs such as the curving, knotty tree, the curious fungus which envelops it, and the craggy root or rock in and on which the birds perch. The painterly use of ink and brush represents an attempt to imitate Chinese technique. Yet, the conception of this drawing and the sinuous treatment of the flowers and stems on the right-hand side, not to mention the somewhat later border, rely on that most Islamic of designs, the arabesque.

 While some fifteenth-century Chinoiserie drawings such as these pheasants were arguably produced as complete works of art, many others were sketches intended for transfer to other media or to 40 larger compositions. A drawing of two fabulous lions could have served as a model for a section of a bookbinding, manuscript borders or even a textile design. Such was the appeal and ubiquity

37 'Two pheasants in a landscape'. Timurid, Herat?, early 15th century. Drawing 24.4 × 28.6 cm. This drawing has several close counterparts in an album in Berlin, which contains many designs for bookbindings and textiles.

63

38 'Hunting scene', from a *Humay and Humayun* of Khwaju Kirmani. Timurid, Shiraz or another provincial centre, 1427. Page 15.2 × 9.1 cm. Unlike the late 14th-century illustrations of Khwaju Kirmani's mystical poem, this painting and others from the same manuscript rely on the standard repertoire of princely themes: hunting, battles, and enthronement scenes.

39 OPPOSITE 'Courtiers by a stream', the left-hand side of an enthronement scene. Timurid or Sultanate, Shiraz or India, 1440s. 18.1 × 11.3 cm. This painting has been divided into two parts, so that the object of the figures' gaze is unseen. In fact, they are looking at a king enthroned in a garden pavilion.

40 'Two fabulous lions'. Timurid, Herat?, early 15th century. Drawing 4.4 × 10.7 cm. Fabulous lions, phoenixes known as simurghs, dragons and other imaginary beasts were borrowed and adapted by Persian artists in all media in the 15th century.

41 A *ghazal*. Timurid, Shiraz, mid-15th century. 17.4 × 7 cm. The *ghazal*, or ode, is one of the primary verse forms in classical Persian. Usually *ghazals* are erotic or mystical in content.

of Chinese floral and animal motifs that artists and craftsmen throughout the fifteenth century incorporated them at every opportunity.

By the mid-fifteenth century the formulae introduced by the artists of Iskandar Sultan and Baysunghur had become established and codified. Thus, collections of *ghazals*, a form of Persian love poetry, were generally written in manuscripts of tall, narrow format and small size, essentially pocket anthologies. The borders of the pages were stencilled with geometric, vegetal or fanciful designs. Here, the angels in vines and arabesques are outlined in gold on tinted paper, a design also found on a page of *ghazals* in the Museum of Fine Arts, Boston, presumably from the same manuscript.

41

Timurids and Turkmans

After the death of Shah Rukh in 1447 internecine strife once again erupted over the question of succession. Ulugh Beg, the virtually independent governor of Samarkand, took Herat and deported Shah Rukh's artists to his own city. Within two years of wresting control of the Timurid realm, Ulugh Beg had fallen victim to a plot by his own son ʿAbd al-Latif. In 1449 he was executed and another period of instability ensued.

By 1451 ʿAbd al-Latif had himself been killed and the Timurid throne passed briefly to one of Shah Rukh's descendants and then to Abu Saʿid, a great-grandson of Timur in the line of his son Miranshah. Most of Abu Saʿid's eighteen-year reign was spent trying to secure former Timurid territories. For eight years he attempted to take Herat; he kept a firm hold only over Transoxiana and Khurasan, and a tenuous footing in Mazandaran and Sistan. Western and southern Iran had by the mid-fifteenth century come under the sway of the Qaraqoyunlu (Black Sheep) Turkmans, whose leader Jahan Shah even managed to occupy Herat briefly in

1458. In 1467 the balance of power shifted again in western Iran when Uzun Hasan, the leader of the Aqqoyunlu (White Sheep) Turkmans, killed Jahan Shah in battle. Thinking the time was right for reasserting Timurid rule in the north-west, Abu Sa'id invaded Azarbaijan. His gross underestimation of Turkman power led to his death and a further contraction of the Timurid empire.

As one might expect of a period in which the control of various regions of Iran was at times in the hands of the Timurids and at times in those of the Turkmans, artists moved from one court to another depending on the availability of patrons. Thus, between the death of Shah Rukh in 1447 and the accession of the last Timurid ruler, Sultan Husayn Bayqara, in 1470, almost no illustrated manuscripts were produced that can with any certainty be assigned to Timurid patronage. Apparently, the Turkman courts at Tabriz, Shiraz and Baghdad offered more attractive opportunities for artists in the 1450s and 1460s than did the embattled Timurid court at Herat. Moreover, in the 1450s Jahan Shah steadily enlarged his dominions, securing western Iran, Fars, Kirman and Isfahan in addition to continuing to hold sway in Azarbaijan. Thus, artists from cities such as Shiraz, Tabriz, Isfahan and Yazd became available to the Turkmans. Perhaps because Jahan Shah was occupied with conquest, no unified style emerged in the 1450s. Instead, a single manuscript, such as a *Khamseh* of Nizami, could contain some illustrations in the Shiraz style of Ibrahim Sultan's artists and some paintings in the Herat style of the Baysunghur period.

42

The rebellious son of Jahan Shah, Pir Budaq, provided the environment and guidance necessary to consolidate the various stylistic strains present in manuscript illustration of the 1450s. Having defied his father while governor of Shiraz, Pir Budaq was appointed to Baghdad in 1460. The illustrations to two manuscripts produced during his tenure there provide the link between the earlier Herat style of Baysunghur and Muhammad Juki (see figs 35 and 36) and the later style of Sultan Husayn's artists. A *Khamseh* of Jamali, copied in 1465 at Baghdad, owes much to earlier Herat painting, especially in the proportions of the figures, landscape details such as flowering trees silhouetted on a gold sky, and the careful execution of the illustrations. However, the expressive interaction and supple poses of some figures and the inclusion of humorous vignettes all anticipate the work of the atelier of Sultan Husayn.

44

Unfortunately, Pir Budaq brought about his own untimely end in 1465 by rising up once more against Jahan Shah, whose troops then invaded Baghdad and slew the rebel prince. Within two years Jahan

42 'Iskandar visiting the hermit', from a *Khamseh* of Nizami. Timurid, Shiraz, mid-15th century. 21 × 12.1 cm. Seeking advice on how to take a fortress near Darband, Iskandar set out at night with an attendant to find a sage who lived in a cave. When he reached the cave, he entered and kneeled before the hermit, who had recognised him as the king. Following the sage's prayers, the door of the besieged fortress opened and Iskandar's forces took control of it. London, Royal Asiatic Society.

43 OPPOSITE 'Fariburz comes before Kay Khusrau', from the 'Big-Head *Shahnameh*', of Firdausi. Turkman, Gilan, 1494. 24.4 × 16.2 cm. Fariburz and Kay Khusrau were rivals for the Iranian throne. To determine who would prevail, King Kay Kavus promised the throne to the one who could storm the enemy fortress of Bahman. Eventually with divine intervention the castle wall collapsed, and Kay Khusrau won the crown.

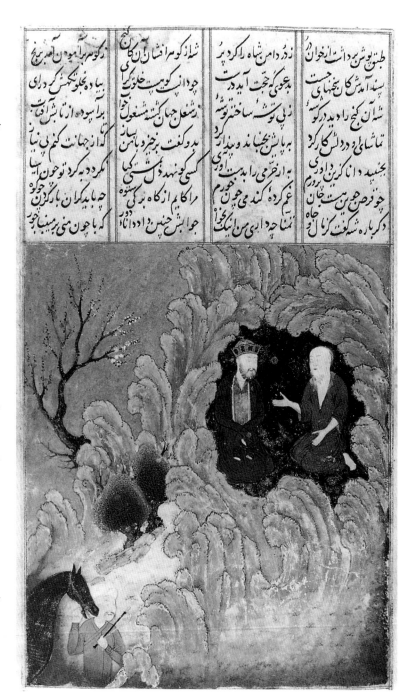

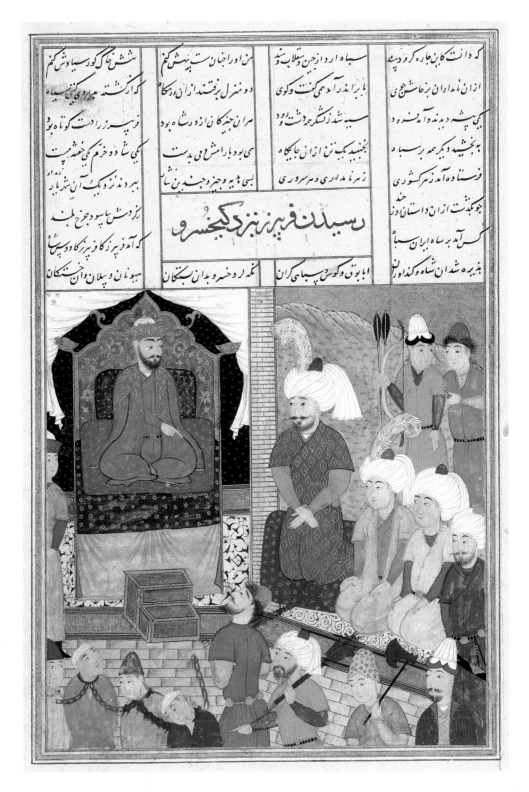

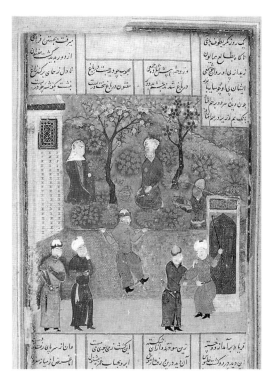

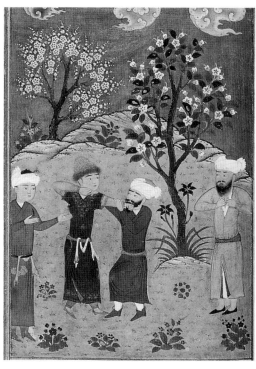

44 ABOVE LEFT 'Humay and Humayun in a garden', from a *Khamseh* of Jamali. Turkman, Baghdad, 1465. Page 33 × 26 cm. Jamali's inclusion of Humay and Humayun in his *Khamseh* may indicate that his inspiration was Khwaju Kirmani. London, India Office Library.

45 ABOVE RIGHT 'Bisati, rending his robe, is overcome by jealousy of his rival', from an *Anthology*. Turkman, Shamakha (Shirvan), 1468. Page 22.9 × 12.4 cm. The poet Bisati of Samarkand (d.1412–13) belonged to the circle of lyric poets led by Kamal Khujandi. British Library.

Shah was himself murdered by his rival Uzun Hasan, and the Aqqoyunlu Turkmans replaced the Qaraqoyunlu as the dominant force in most of Iran. Although there are written accounts of wall-paintings in Uzun Hasan's palaces at Tabriz, his capital, the only illustrated manuscript to bear his name is one that his son Khalil ordered to be completed and dedicated to him. Nonetheless, fine manuscripts were produced for a variety of other patrons during his reign (1467–78). One such elegant, small manuscript is an *Anthology* copied in 1468 by the scribe Sharaf al-Din Husayn at Shamakha in the province of Shirvan. Farrukh Yasar, the ruler of Shirvan and presumed patron of the book, recognised Turkman authority, but Shamakha was a wealthy trading post near the Caspian which might well have attracted artists from other Turkman centres. While the orderly poses and groupings of figures in the Shamakha *Anthology* relate to Timurid painting, their proportions, with large heads resting on slender necks and small bodies, anticipate later Turkman paintings. Furthermore, the spirited palette, billowy fungal clouds and occasional ebullient floral spray look forward to the high Turkman style of the last quarter of the fifteenth century. By the end of the fifteenth century the Turkman style was fully established at Shiraz, where large numbers of manuscripts were produced not for individual patrons

but for sale in the marketplace. The quality of most commercial Turkman manuscripts does not match that of books commissioned by rulers and wealthy individuals. Nevertheless, the sheer quantity of illustrated books produced in Shiraz ensured the dissemination of the Turkman style throughout Iran and in Ottoman Turkey and Muslim India as well.

Among the distinctive Turkman illustrated manuscripts of the late fifteenth century is a *Shahnameh* copied in 1494 for Sultan ʿAli Mirza of Gilan, another Turkman feudatory in the Caspian region. The nearly 350 miniatures from this manuscript are rendered in two styles, one of which is characterised by figures with excessively large heads. As a result, the manuscript is commonly called the 'Big Head *Shahnameh*'. Although 'Fariburz comes before Kay
43 Khusrau' does not include figures with outsized heads, it exhibits the other traits that typify the manuscript: a bright, light palette; robust, large-scale figures, evenly placed tufts of grass, and a blithe disregard of realistic spatial relationships. As one would expect of a special commission, the painting has been rendered with meticulous care and more varied detail than commercial Turkman pages.

46 The final royal Turkman manuscript, a *Khamseh* of Nizami, provides a link not only with Timurid painting and patronage but also with the early years of Safavid painting. A long note in the manuscript states that it was originally produced for the Timurid prince Babur b. Baysunghur (d. 1457). It passed into the hands of the Aqqoyunlu Turkman Khalil, who ordered its continuation for his father Uzan Hasan. Upon Khalil's death in 1478, his brother, Yaʿqub Beg, received it, but eventually, still unfinished, it was taken by Yaʿqub Beg's arch-enemy, the first Safavid Shah, Ismaʿil, following his defeat of the Aqqoyunlu. The miniatures from the period of Yaʿqub Beg reveal a greater affinity with some of those of the Shamakha manuscript than to those of the 'Big Head *Shahnameh*'. Though larger and far more complex in composition than the Shamakha *Anthology*, the *Khamseh* includes similar figures with very slender necks. The presence of angels, a harpist, and a gardener who almost does a jig as he works are novel additions to a scene whose antecedents go back to Jalayirid painting (see fig. 24). Compared to the more sober Herat School miniatures of the same period, this painting and its fellow illustrations in the *Khamseh* redound with surprising juxtapositions of colour and compositional anomalies that nonetheless combine to produce deeply appealing pictures. One such oddity is the night sky found within the borders but not outside them, as if Khusrau were in a different time zone from Shirin. In fact, at its best, late fifteenth-century

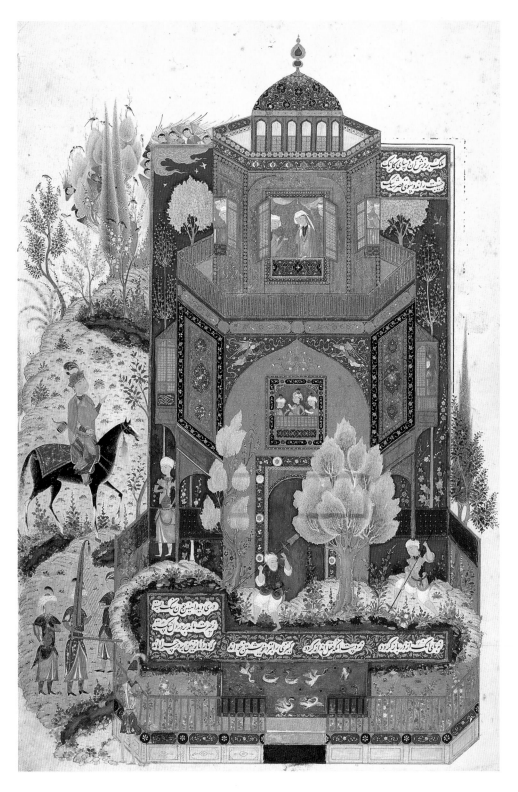

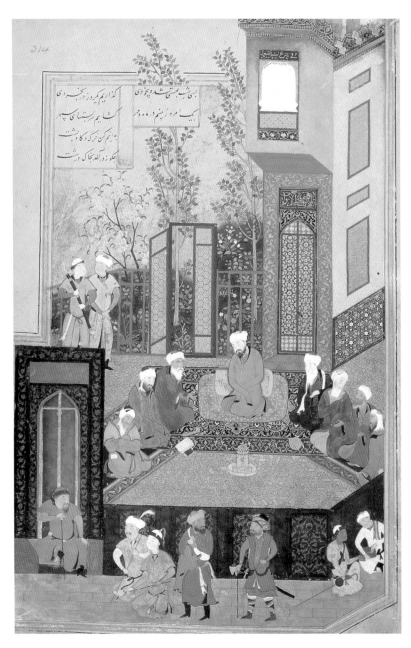

46 OPPOSITE 'Khusrau at Shirin's palace', from a *Khamseh* of Nizami. Turkman, Tabriz, late 15th century. Page 29 × 19 cm. The subject of Khusrau before Shirin's palace was a perennial favourite of Persian painters, for it enabled them to combine architecture with landscape and include a variety of figures. Keir Collection.

47 'Iskandar and the Seven Sages', attributed to Bihzad, from a *Khamseh* of Nizami. Timurid, Herat, 1494–5. Page 24.1 × 16.8 cm. Much of the narrative of the *Iskandarnameh* concerns the wondrous sights and strange events that occurred in the far-flung places to which Iskandar travelled. Here he confers with the seven sages before setting out across the Western Sea. British Library.

Turkman painting demonstrates an understanding of nature which is as intuitive as Timurid painting of Herat was rational.

Just as Turkman painting flourished in the reign of Ya'qub Beg (1478–90), so the accession of Sultan Husayn Bayqara to the Timurid throne in 1470 ushered in a brilliant period of painting in Herat. Wisely content to rule the lands between the Caspian and the Oxus, Sultan Husayn, the ultimate successor to Abu Sa'id, managed to keep his throne for thirty-six years. In the face of mounting Turkman power in the west, continued insurgency on the part of rival Timurids in Transoxiana and the rise of the Uzbeks in the east, his ability to maintain a stable rule from Herat ranks as a notable achievement. Despite the constant military and political threats to Sultan Husayn's rather small realm, he gained the abiding support of the people of Khurasan by stimulating economic prosperity and ensuring the safe passage of traders and other travellers. The calm and well-being of Herat enabled Sultan Husayn to develop his own penchant as a patron of literature and the arts. With his vizier, Mir 'Ali Shir Nawa'i, Sultan Husayn sponsored the birth of Chaghatai (eastern) Turkish as a literary language, and patronised two of the most important figures in the history of Persian culture, the poet Jami and the artist Bihzad.

The elegance and refinement which characterise Herat paintings in this period reflect the complex and mannered society of Sultan Husayn's court. At royal gatherings guests were not only seated according to rank but also were expected to conform to strict rules of etiquette when discussing fine points of poetry, music or art. Within these strictures there thrived a highly intellectual and literate coterie. The painting of the period gives no hint that the court was in fact declining in political significance, as if the last Timurid ruler and his subjects had purposely turned their backs on the troubled world that lurked outside Khurasan.

By far the most famous and influential painter at the court of Sultan Husayn was Kamal al-Din Bihzad of Herat. An orphan, Bihzad was reared and trained by the artist Mirak Naqqash, who distinguished himself as a painter but also enjoyed weight-lifting and other sports. A single sixteenth-century voice of dissent notwithstanding, Bihzad has been universally recognised as peerless, the 'pride of the ancients in illumination and outlining, the rarity of the age' (Thackston, p. 347). He lived to the age of about 75, and had a number of successful students who worked in a style closely related to his. As a result, much discussion has centred on questions of the date and authenticity of works attributed to him. Although he most likely began his career in the early 1470s, the great majority of his work dates from the 1480s and 1490s. Thanks

to a *Bustan* of Sa'di of 1488–9 in Cairo, with four miniatures signed by, as opposed to attributed to, Bihzad, illustrations in at least seven other manuscripts can be assigned to him.

Rather than investigate Bihzad's stylistic development, a general study of late Timurid painting must focus on his innovations. While maintaining the rational spatial relationships and meticulous depiction of ornamental detail characteristic of the manuscripts illustrated for Baysunghur, Bihzad humanised the style by giving his figures realistic gestures and telling looks. The painting of 'Iskandar and the Seven Sages' from a *Khamseh* of Nizami of 1494–5 is a case in point. Iskandar, who sits in the centre of the scene, is probably a portrait of Sultan Husayn Bayqara. The sages arrayed to his right and left may also be based on actual people, for each differs markedly from the next. The one at the far left huddles in his shawl as if suffering from circulatory problems whereas the man closest to Iskandar gestures openly with both hands. These men vary not only in age but also in their complexions, which range from tawny brown to pink and nearly white. In contrast with the staid gathering within the walls, life in its variety carries on outside. A properly burly gatekeeper blocks the entrance to the palace while chatting with two friends. Meanwhile, an encounter of a different sort takes place between a gaily clad soldier and a city dweller holding a teapot. Bihzad's paintings are consistently enlivened by such vignettes, which add flavour and interest to his scenes even if they do not literally illustrate the narrative. Although certain figural traits, such as hunched shoulders and arms held out from the torso, occur regularly in his *oeuvre*, underlying his work is a gift for variety within the constraints and canons of Persian academic painting; indeed, he relaxed the formality of court art. Yet, as his contemporaries recognised, he contributed a new vision to his school and fundamentally changed the course of Persian painting. Complex but not confusing, gloriously colourful yet realistic, Bihzad's work represents for many the high point and even the epitome of the Persian miniature.

47

— 4 —

A GLORIOUS
SYNTHESIS

1500–1576

Early Safavid Rulers

As the thirty-six-year reign of Sultan Husayn came to an end upon his death in 1506, new forces were on the rise to the east and to the west of the Timurid domain in Khurasan. From beyond the river Jaxartes the Uzbeks, led by Muhammad Shaybani Khan, advanced steadily toward Herat, taking it in 1507, within months of Sultan Husayn's demise. Meanwhile, in Gilan, Isma‘il, the barely adolescent grandson of the Aqqoyunlu Uzun Hasan, had rallied a following of Qizilbash (literally 'red-head'), so-called for their distinctive red *taj* or turban and baton headgear. Their first mission was to avenge the murder of Isma‘il's father at the hands of an Aqqoyunlu-Shirvanshah alliance. Reared by a Shiite prince in the Gilan region, Isma‘il also traced his ancestry to Shaykh Safi al-Din, the founder of a Sufi order at Ardabil which had become wealthy and powerful by the mid-fifteenth century. Thus, Isma‘il had a ready following in the adherents to Shaykh Safi°'s sect, the Safavids. His charismatic personality and ecstatic Shiite religious beliefs, in which he enjoyed semi-divine status, appear to have provided the messianic edge necessary for him and his Qizilbash followers to defeat the Aqqoyunlu in 1501 at Sharur in Azarbaijan. Seemingly intent on controlling all the former Turkman lands, Isma‘il had taken Western Persia and Eastern Anatolia by 1508, the year in which he added Baghdad and Khuzistan to his conquests.

Fearing the vigour of the Uzbek advance on Khurasan, Isma'il next turned his attentions eastward. In 1510 he defeated and killed Muhammad Shaybani Khan in a battle near Merv. Rather than continue into Transoxiana, Isma'il's forces stopped at the river Oxus, and the Safavids became masters and heirs of the former Timurid domain of Khurasan. Despite a defeat at the hands of the Uzbeks in 1512, the Safavids maintained fairly stable control of Khurasan for the rest of Shah Isma'il's reign. The same could not be said of his western borders.

In 1512 the Qizilbash of Ottoman Anatolia revolted against the Turkish Sultan Bayezid with help from the Safavids. The Sultan's son and successor, Selim, decided both to suppress the revolt and to deal with the Safavids. With a large, well-equipped army he marched across Anatolia and into Azarbaijan, where he finally confronted Isma'il in battle at Chaldiran near Tabriz in 1514. Not only did the Ottomans outnumber the Safavids, but they enjoyed the decisive advantage of technological superiority: they had guns. The implications of the ensuing rout were far-reaching for the Safavids. Eastern Anatolia passed permanently into Ottoman hands, causing an eastward shift of the Safavid realm. The once invincible Isma'il never again fought in battle, though he still maintained his support amongst the Qizilbash. Even for the arts of the book, Chaldiran and the ensuing sack of Tabriz had serious results, for the Ottomans carried off all kinds of loot including manuscripts and artists.

From the Safavid point of view, at least one positive event occurred in 1514: the birth of Isma'il's son and heir, the future Shah Tahmasp. Sent at the age of two as nominal governor of Herat, Tahmasp was brought up there in the refined, intellectual environment established under Sultan Husayn Bayqara. The artist Bihzad was still working there, and may himself have been responsible for the young prince's artistic training. Certainly from an early age Tahmasp showed an intense interest in painting and calligraphy, predilections which led to the next efflorescence of Persian painting.

As one would expect, Shah Isma'il's taste in painting ran to the Turkman idiom prevalent at the court of Ya'qub Beg and 46 represented by the illustrations to the *Khamseh* of Nizami owned by successive fifteenth-century rulers. Isma'il himself had eleven 48 miniatures added to the manuscript. These are differentiated from the late Turkman paintings in the manuscript only by the presence of the high Safavid *taj*. The vibrancy of pose, colour and composition continued in the Safavid period, and, if anything, became more visionary, as if to mirror the highly energised spirituality of Shah Isma'il's politico-religious beliefs.

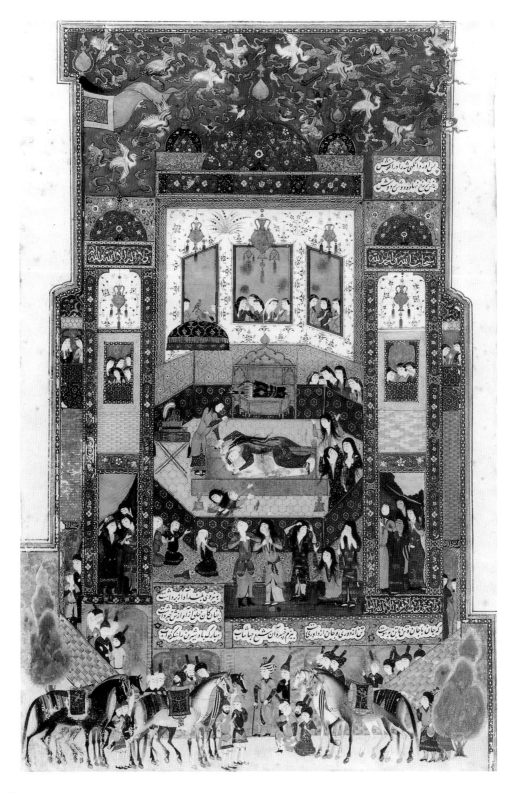

In 1522 Tahmasp moved from Herat to Tabriz, and it was most likely before this date that Shah Isma'il commissioned an illustrated *Shahnameh* to be produced in his atelier. Although the chain of events is uncertain, it seems that some of the miniatures were complete by 1522. However, the project was unfinished at the time of Shah Isma'il's death in 1527 and was subsequently transferred to the patronage of Shah Tahmasp. Since Tahmasp was only 10 years old at the time of his accession, the political affairs of the Safavid state were controlled by various Qizilbash atabegs and amirs, leaving the young Shah plenty of time to pursue his aesthetic interests. During the twenty-odd years from 1515 until the late 1530s in which the royal *Shahnameh* was produced, early Safavid painting was born and reached maturity.

49 A painting of 'Rustam sleeping while Rakhsh fights the lion' was probably intended for Shah Isma'il's unfinished *Shahnameh*. The phantasmagoric vegetation and rocks, all intensely coloured, and the rhythmic, energetic complexity of the composition characterise the metropolitan Turkman style at its best. In contrast to the somnolent Rustam, the rocky outcrops teem with simian, human and feline faces. A snake feeds upon a bird's young, his sinuous form echoed by writhing branches and the lion's switching tail. As in earlier Turkman painting, spatial relationships matter far less than the expression of emotion. In this painting, with the good horse Rakhsh overcoming the evil lion, the forces of nature rule supreme. Man, in the person of the hero Rustam on his carpet, all angles and straight lines, is in marked contrast to the swaying, vibrating flora and fauna.

To the young Tahmasp, schooled in the sober, rational milieu of Herat, the painting of Turkman Tabriz must have seemed wild and perhaps discomforting. Assuming that Bihzad and other younger artists accompanied Tahmasp from Herat to Tabriz, one would necessarily expect a change of direction in the style of Safavid painting. The fact that 'Rustam sleeping', which has been attributed to Sultan Muhammad, one of the leading court painters of Shahs Isma'il and Tahmasp, was not eventually included in Shah Tahmasp's *Shahnameh* must indicate that it did not suit the young Shah's taste. Yet, with consummate skill Sultan Muhammad adapted his style to the Bihzadian mode. His early illustrations to the *Shahnameh* combine the joyous palette, humour and animism of Turkman painting with the structure and finesse of the Herat style. By about 1530 the two strains were fully synthesised in his work. Man and nature were now in balance, though more than his contemporaries Sultan Muhammad reflected the mood and meaning of the narrative in rocks, plants and skies.

48 'The suicide of Shirin', from a *Khamseh* of Nizami. Safavid, Tabriz, c.1505. Page 29.5 × 19 cm. After they were finally wed, Khusrau and Shirin ruled Iran happily for many years. Yet, eventually, the son born to Khusrau by his first wife grew up and vowed to seize the throne. He had Khusrau imprisoned and then assassinated. After Khusrau's funeral, his bier was placed within the royal vault, where Shirin stabbed herself and lay down to die on top of the golden coffin. Keir Collection.

49 'Rustam sleeping while Rakhsh fights the lion', style of Sultan Muhammad, from a *Shahnameh* of Firdausi. Safavid, Tabriz, *c.*1515–22. 31.6 × 20.8 cm. To rescue Shah Kay Kavus from captivity, Rustam and his horse Rakhsh chose a direct but perilous route. Overcome by fatigue, Rustam lay down in a pasture that was actually a lion's lair. As the hero slept, the lion returned and attacked Rakhsh, who ultimately trampled him to death.

50 OPPOSITE 'Sultan Sanjar and the old woman', from a *Khamseh* of Nizami, attributed to Sultan Muhammad. Safavid, Tabriz, 1539–43. Page 36.5 × 25.1 cm. An old woman complained to the Seljuk ruler Sultan Sanjar (r. 1119–56) that she had been robbed by one of his soldiers. The sultan replied that her grievance was trivial compared with the problems of his latest military campaign. She responded, 'What use is the conquest of foreign armies when you cannot make your own behave?'. British Library.

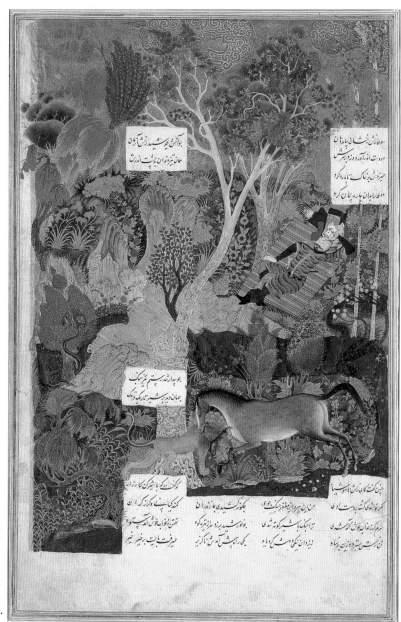

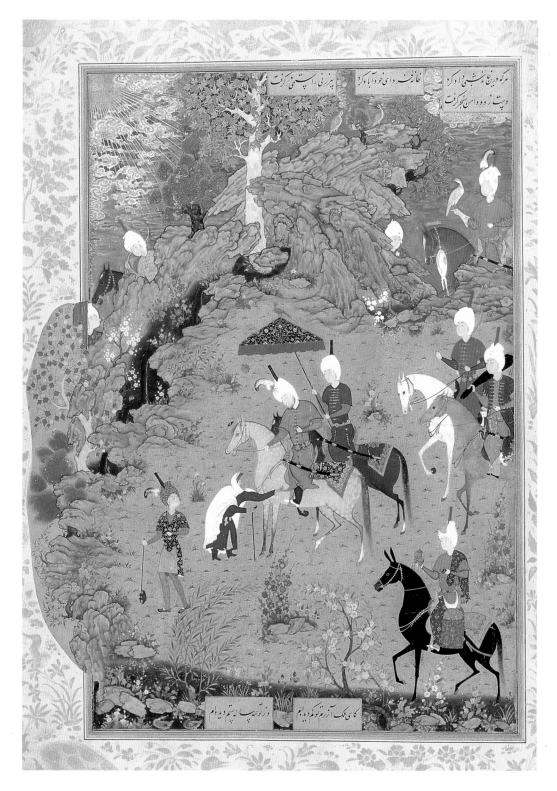

An undertaking as ambitious as Shah Tahmasp's *Shahnameh* with its 258 illustrations and 380 folios required a sizeable staff of painters, illuminators, calligraphers, gilders, binders and helpers. All the leading artists of the day were involved in the manuscript, and in some cases two generations from one family contributed paintings to it. When the project was complete some of the artists were engaged to work on other royal commissions, whereas others were employed by members of the royal family other than the Shah himself.

By 1539, the date of the Shah's next major manuscript, much had changed in Iran. Tahmasp had come of age, repelling five Uzbek invasions between 1524 and 1537. Qizilbash factionalism also added to the general instability of the Shah's regime until 1533, when he overthrew his Qizilbash regent and had him executed. A greater threat to the Safavids, an Ottoman invasion, materialised in 1535 and resulted in the loss of Mesopotamia and Baghdad. Fortunately, Tahmasp devised a strategy which would serve him well in future Ottoman invasions. Rather than engage the Ottomans in battle, as his father had done with such disastrous results, he followed a scorched earth policy with the aim of overstretching the Ottoman lines of supply so that they would eventually be forced to retreat, allowing the Iranians to reclaim their territory.

In keeping with the new maturity of the Shah, the illustrations to his 1539–43 *Khamseh* of Nizami exhibit a uniformity of style and 50 unity of vision that define the classical moment of this school. Sultan Muhammad's paintings in this manuscript exhibit subtle modifications of the style of his *Shahnameh* illustrations. While continuing to render rocks, trees and sky in a dramatic fashion, he slightly enlarged the scale and reduced the number of his figures. Their poses are more self-contained, though no less expressive than those of their predecessors. In keeping with the style of the day, the horses and figures – with the exception of the old woman – in the example illustrated are tall and slender but not mannered.

Although Shah Tahmasp's artists were primarily involved with his grand manuscript projects in the 1530s and early 1540s, they also painted single-page works on occasion. One such painting, a portrait of Sarkhan Beg Sufrachi (the table-layer), is signed by or 52 ascribed to Mir Musavvir, mentioned in the historical sources as one of the directors of Shah Tahmasp's *kitab khaneh*. Despite the paint loss on the figure's face, Mir Musavvir's meticulous attention to detail is amply evident in the rendering of the striped turban and filigree belt ornaments. In keeping with the Persian canon for portraiture, the artist has made no attempt to define the form of Sarkhan Beg's features through modelling. Instead the physique,

clothes, pose and facial expression must have served to identify him. The inscription, perhaps a later addition, would have been superfluous at the time the portrait was painted.

53 Another portrait, 'A prince and a page', provides an interesting point of comparison with that of Sarkhan Beg. Attributed to Mir Sayyid ʿAli, son of Mir Musavvir, this painting was executed about 1540, a decade later than 'Sarkhan Beg'. Like his father, Mir Sayyid ʿAli was a master of intricate detail, lovingly depicting every fold and stripe of the prince's turban. Moreover, the prince's pose is identical to that of Sarkhan Beg. Only the sublest of details differentiate the later from the earlier work. In Mir Sayyid ʿAli's painting the figure of the prince is slimmer than that of Sarkhan Beg, though originally his physique was stockier and the artist repainted it. The prince's robe is adorned with large gold lotuses instead of small repeated circles. The treatment of rocks in Mir Sayyid ʿAli's painting also resembles that in one of the illustrations he contributed to Shah Tahmasp's *Shahnameh*. Even if they were not abraded, the faces would appear idealised to modern eyes, but, like that in the earlier work, they must have been recognisable to contemporaries.

One historical event bears out the supposition that the work of both Mir Musavvir and Mir Sayyid ʿAli was prized above all for its faithfulness to material reality. In 1544 the Mughal emperor Humayun sought refuge at the Safavid court at Tabriz. When it came time for him to return to India, he invited Mir Musavvir to join his entourage. Before Mir Musavvir could depart, Mir Sayyid ʿAli had also taken advantage of the offer, leaving his father to follow. When these two artists and several others from Shah Tahmasp's atelier ultimately reached Delhi, their accurate, careful mode of painting contributed enormously to the new school of Mughal painting, a more naturalistic mode in which Safavid, Bukharan, Hindu and Muslim Indian styles were synthesised.

Had Humayun arrived in Iran ten years earlier, Shah Tahmasp would probably not so willingly have released two of his best artists. However, by the mid-1540s his interest in painting had waned, and he had become an increasingly devout Muslim. Having sworn off intoxicants in the mid-1530s, the Shah had also become disenchanted with painting and calligraphy by the mid-1540s. Tahmasp's distaste had turned to disgust by 1556, the year of his Edict of Sincere Repentance, in which he outlawed the secular arts throughout his lands. Since the Shah had repulsed yet another Ottoman assault in 1554 and had signed the Treaty of Amasya with the Ottomans in 1555, his edict may also represent a form of pious thanks for the safety of his realm. However, in spite of the edict,

51 'A prince visiting a holy man', from a *Matlaᶜ al-Anvar* of Amir Khusrau Dihlavi. Safavid, Qazvin, *c.*1560–70. Page 22.5 × 16.4 cm. The *Matlaᶜ al-Anvar* of Amir Khusrau was modelled on Nizami's *Makhzan al-Asrar* and forms the first book in his *Khamseh*. Although the episode illustrated here does not depict Iskandar, the imagery is certainly borrowed from earlier depictions of the king and a sage.

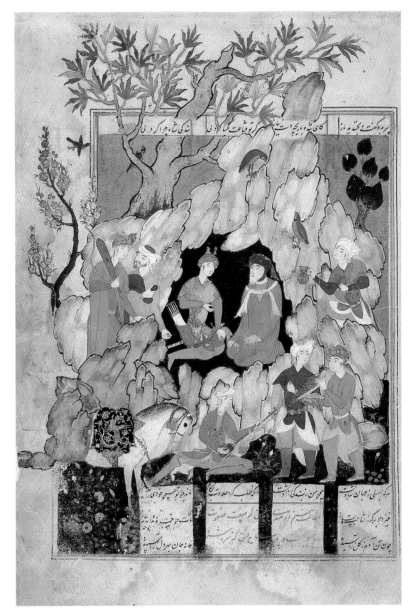

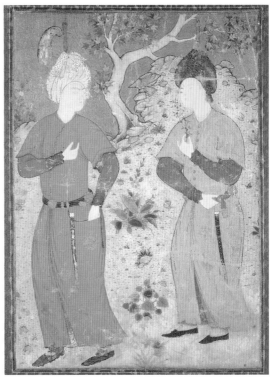

artists continued to illustrate manuscripts. Many of the court artists who did not emigrate to India went instead to the court of Tahmasp's nephew, Sultan Ibrahim Mirza, at Mashhad. Ibrahim Mirza served as governor of Mashhad until 1564, during most of which time his artists worked on an illustrated *Haft Aurang* of Jami. Even after he was demoted and transferred to the minor city of Sabzavar, Sultan Ibrahim continued to patronise the arts. Certain mannerist tendencies characterise the paintings of his court artists and of lesser hands working in the same style. The size of heads has now decreased in proportion to bodies, and cheeks are less ovoid and more pouch-like than those in paintings of the 1540s. By the late 1560s the distinctive Safavid *taj* and high turban were no longer the only choice of headgear. Fashionable youths also donned low turbans or fur caps wrapped with a bit of cloth. Rocks and trees ceased to contain hidden grotesques but appeared slippery and somewhat insubstantial.

Toward the end of his life Shah Tahmasp retreated somewhat from his radical anti-painting stance. In the 1550s he had transferred his capital from Tabriz to Qazvin, and there a school of painting developed which followed a similar course to that of Mashhad and Sabzavar. While eschewing the mannerist excesses of

51

52 ABOVE LEFT
'Sarkhan Beg the Chamberlain', signed by Mir Musavvir. Safavid, Tabriz, c.1530. 33 × 22 cm. Scholars have read the sitter's name variously as Sarkhan, Murkhan and Mirkhan Beg. See also fig. 5.

53 ABOVE RIGHT
'A prince and a page', attributed to Mir Sayyid 'Ali. Safavid, Tabriz, c.1540. 37.5 × 26.7 cm. The prince, with a feather in his turban, appears about to accept a posy from his companion. The painting was intended for inclusion in an album.

85

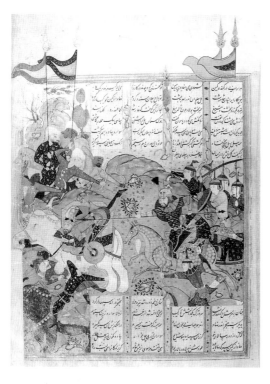 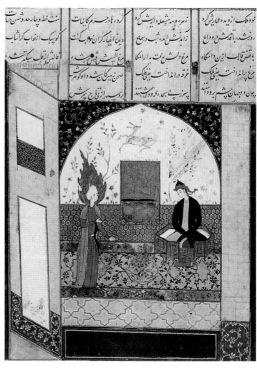

54 ABOVE LEFT
'Garshasp throwing
Jaipal off his elephant
in battle', from a
Garshaspnameh of
Asadi. Safavid, Qazvin,
1573. Page 25 × 21.5 cm.
The story of Garshasp
is a picaresque tale of
battles fought and
wonders seen in Iran,
India and China. British
Library.

55 ABOVE RIGHT 'Yusuf
appears before
Zulaykha'. Safavid,
Shiraz, c.1570.
19.9 × 12.4 cm. Yusuf,
the biblical Joseph, was
so beautiful that his
appearance before
Zulaykha, Potiphar's
wife, utterly befuddled
her. Persian painters
always depict Yusuf
with a flaming halo.

Sultan Ibrahim's artists, the illustrators of the *Garshaspnameh* of 54
Asadi of 1573 nonetheless maintained the facial types of the 1560s,
especially youths with incipient double chins. Compositions lost
some of the complexity of the 1560s, and figures were rendered
larger in scale and closer to the picture plane. Bright, saturated
colours prevailed.

By contrast, Shiraz painting of the 1560s and 1570s exhibits an
aesthetic distinct from that of the Safavid court. A city of enduring
artistic vitality, Shiraz had held its position as the centre of
commercial manuscript production throughout the sixteenth cen-
tury, and its artists painted in a range of styles from conservative
Turkman to more up-to-date reflections of Safavid court painting.
In the 1560s and 1570s progressive Shiraz artists adopted the
elongated forms of Qazvin painting, but stressed two-dimensional
and decorative values rather than space and volume. They also 55
preferred mauve, pink, yellow and other pastel colours to the richly
modulated hues of Safavid court art. Although some Shiraz
paintings depict highly complex, large-scale scenes, the figures are
often small in scale and portrayed in agitated poses. The great
majority of paintings surviving from the late sixteenth century are
from Shiraz.

One other regional school worth noting thrived in the sixteenth

century: that of Bukhara. Having fallen to the Uzbeks in 1500, Bukhara remained in their hands until 1510, when Shah Isma'il killed their leader Shaybani Khan. By 1512, however, 'Ubayd Allah Khan had regained the city for the Uzbeks, who controlled it more or less continuously until the twentieth century. Although illustrated manuscripts produced for Shaybani Khan reveal Turkman influence, presumably introduced through the medium of commercial Shiraz manuscripts, by the 1520s the influence of the Bihzadian style of Herat had prevailed. In a miniature from a *Khamseh* of Amir Khusrau Dihlavi the contribution of Herat painting to the Bukhara school is amply evident. The figures and landscape have been rendered with extreme care. The regularly placed tufts of grass and minimal rocky outcrops contrast notably with the ebullience of Safavid landscapes, and the figural types adhere to the Bihzadian mode, solidly built with varied facial expressions. Yet, the round-faced, small-mouthed boy in the centre foreground is a type that comes to embody the youthful Bukharan norm in the middle of the century. Compositions based on horizontal bands of land and rows of figures also become increasingly common in Bukharan painting.

56

56 BELOW LEFT 'Young men overcome by thirst in a desert', from a *Khamseh* of Amir Khusrau Dihlavi. Bukhara, *c*.1530. Painting 20.1 × 14.3 cm. The young men and their camel are rescued from certain death by another man who has miraculously produced a spring of water.

57 BELOW RIGHT 'Lovers'. Bukhara, *c*.1560–70. 19.4 × 12.1 cm. This painting is in the style of 'Abdullah, a pupil of the more gifted artist Mahmud Muzahhib.

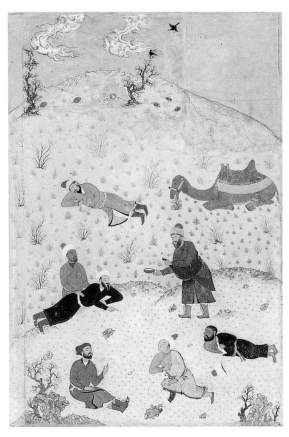

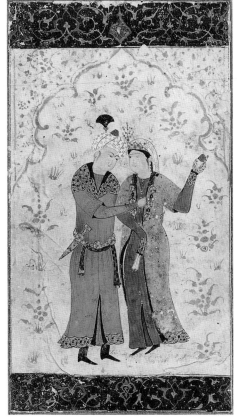

58 'Angel'. Bukhara, c.1555. 18.1 × 10.2 cm. This is the right-hand page of a pair of angels which were removed at some point from an album now in the Fitzwilliam Museum, Cambridge. While angels appear in the earliest Islamic manuscripts and in form derive from classical prototypes, Buddhist elements, such as the trailing sashes and feet as tongues of flame, entered the Persian pictorial vocabulary in the 14th century.

In addition to manuscript illumination, Bukharan painters adorned pages of poetry with figures of young men or women, or loving couples. Although the painting of a couple shown here is 57 probably a commercial version of such works, several characteristically Bukharan features are present. Many paintings of this type depict the figures within an ogival arch and surrounded by illuminated borders. A bright palette was common, and Bukharan illuminators frequently used a black ground as a foil for extremely fine arabesque designs.

Other Bukharan paintings of the third quarter of the sixteenth century reveal a broader, more painterly style. As in the painting of the lovers, the artist of a seated angel has used red to outline the 58 figure and to depict folds of cloth. Yet the angel's face and the arabesque which swirls around her exhibit greater freedom of brushwork and conception. Recently, scholars have remarked on the importance of Bukharan painting for early Mughal painting. Possibly the 'Angel' and the other paintings in the album from which it was removed were painted for Mughal patrons by Bukharan artists or by Persian artists working in the Bukharan style.

— 5 —

A CHANGE OF EMPHASIS

1576–1629

Shah Isma'il II (r. 1576–7) and Shah Muhammad Khudabandeh (r. 1577–88)

Shah Tahmasp was succeeded in 1576 by his second son, Isma'il II. As a punishment for insubordination, Isma'il had been imprisoned by his father for nearly twenty years, and was released only upon Shah Tahmasp's death. Incarceration had hardly prepared Isma'il for leadership. His reign was marked by intense cruelty, aimed in particular at members of his own family. Having killed or blinded five of his brothers and four other royal princes, Isma'il also tried to eradicate any officers who had been loyal to his father. His Qizilbash supporters soon turned against him, and it was probably they who arranged his death from poisoned opium.

Isma'il spared only those princes who were either too young or too dim-witted to be considered a threat. Muhammad Khudabandeh, his successor, belonged to the latter category. Although he was Shah Tahmasp's oldest son, he had been passed over because he was half-blind and deemed unfit to govern. Years of self-indulgence in the harem had rendered him weak and uninterested in ruling Iran. For several years his powerful wife ran the affairs of state, but the Qizilbash faction which opposed her had her murdered. While various tribal groups and Safavid princes were rebelling against the Shah, the Ottomans invaded again in 1578 and over the next decade took much of northern and western Iran. The Uzbeks, meanwhile,

moved back into Khurasan and besieged Herat. By 1587 the parts of Khurasan still free of Uzbek control threw their support behind the governor of Mashhad, Murshid Quli Khan Ustajlu, and his ward Prince ʿAbbas, the Shah's adolescent son. Their revolt spread and soon they entered Qazvin, where Muhammad Khudabandeh abdicated in favour of ʿAbbas.

The reign of Shah ʿAbbas I, which will be discussed at greater length below, has been considered a golden age in Iranian history. Coming as it did on the heels of a period of decline, the forty-year rule of a vigorous, creative Shah stimulated almost every field of endeavour, not least the arts. However, the direction in which miniature painting moved under Shah ʿAbbas was largely determined by the events and artistic climate under Ismaʿil II and Muhammad Khudabandeh. Despite his severe personality defects, to Shah Ismaʿil's patronage may be assigned a *Shahnameh*, now dispersed and most likely unfinished. Although the illustrations do not equal those of Shah Tahmasp's *Shahnameh* in grandeur or beauty, they prove the continuing employment of some of Tahmasp's and Ibrahim Mirza's artists, such as ʿAli Asghar, and the introduction of several artists of the younger generation. Stylistically the paintings of Shah Ismaʿil's *Shahnameh* do not break with the recent past. Like the illustrations to the 1573 *Garshaspnameh*, the 1576–7 *Shahnameh* paintings demonstrate the retreat from the excessive mannerism of Ibrahim Mirza's artists to simpler compositions, hardier figures and a palette of pastel hues punctuated by passages of intense primary colours.

59 A painting of 'Rustam slaying the White Div' from an unknown *Shahnameh* relates closely to the illustrations in Shah Ismaʿil's manuscript, especially those by the artist Murad. By including only the two protagonists, the artist has heightened the drama of the scene. The windswept clouds and soaring rocks reinforce this effect, although their subdued colours ensure their secondary function. The majority of the illustrations, however, contain more figures and otherwise carry on the tradition of Safavid manuscript painting. Yet the illustrations with fewer figures anticipate a trend which flowered more fully in the reign of Shah ʿAbbas I.

The death of Shah Ismaʿil II in 1577 dealt royal manuscript production a nearly fatal blow. Since Shah Muhammad Khudabandeh did not possess the fundamental requirement of a patron of paintings – decent eyesight – he could hardly be expected to prize illustrated manuscripts and the artists who produced them. As a result of the Shah's disinclination, the court artists of Qazvin were forced to seek their living elsewhere. While some must have emigrated to India or Ottoman Turkey, others such as Habibullah,

59 'Rustam slaying the White Div: the Seventh Course', from a *Shahnameh* of Firdausi. Safavid, Qazvin, *c.*1576. Painting 31.5 × 27.3 cm. On his hazardous journey to Mazandaran, Rustam underwent repeated tests of strength, known as the 'Seven Courses'. Told that divs (demons) sleep at midday, Rustam entered the White Div's cave and engaged him in a ferocious battle. Finally, Rustam prevailed and plucked out the Div's liver.

60 OPPOSITE 'Picnic in the mountains'. School of Muhammadi, Herat, 1560s. Painting 22.3 × 14.4 cm. The leaves of the trees by the stream have changed from bright to olive green and have begun to 'burn' the paper as a result of verdigris in the pigment.

Muhammadi, Shaykh Muhammad and probably Sadiqi Beg moved to either Herat or Mashhad. ᶜAli Asghar, father of the great artist Riza, either returned to his native city of Kashan or journeyed to Mashhad. In the decade of Muhammad Khudabandeh's tenure the former court artists turned increasingly to single-page works, as few, if any, patrons could afford lavishly illustrated manuscripts.

Several artists, however, appear to have adapted to the strained conditions of the Muhammad Khudabandeh period and pioneered or popularised new genres. One of these, Muhammadi, worked for ᶜAli Quli Khan Shamlu at Herat. In addition to portraits, Muhammadi produced tinted drawings of country scenes, such as shepherds in the wilderness tending their flocks or courtiers picnicking or being entertained *al fresco*. While the latter scenes derive from illustrations to lyrical manuscripts, the former represent a new subject in Persian painting. Both types of composition were accorded the highest respect by Muhammadi's contemporaries and

followers, who copied and adapted them. In 'A picnic in the mountains' the combination of polychromy for the figures, faces, 60 turbans, belts and various props and landscape elements with drawing for outlining the figures derives from a technique introduced by Muhammadi. Whether this technique was born of economic necessity – a partly drawn, partly painted work would cost less than a completely painted one – is debatable. Whatever the reason, the technique continued to be used well into the seventeenth century, when wealthy patrons once again abounded.

Two other artists, Shaykh Muhammad and Sadiqi Beg, exerted a strong influence on late sixteenth-century painting in Iran. The elder of the two, Shaykh Muhammad, had worked for Shah Tahmasp, Ibrahim Mirza and Shah Isma°il II, spending the Muhammad Khudabandeh years in Khurasan. In addition to his demonstrable ability to adjust his style to suit the taste of the day, Shaykh Muhammad introduced a distinctive form of draughtsmanship. The ends of sleeves form worm-like folds that fairly wriggle up his figures' wrists. In some drawings the free calligraphic rendering of hems and sashes implies movement and puffs of wind. Despite Qazi Ahmad's remark that Shaykh Muhammad 'made some mistakes' in portraits (Qazi Ahmad, p. 187), his likenesses must have borne a strong resemblance to his sitters as they differ markedly from one another and do not conform to any set type. By the time Shah °Abbas I came to power in 1587, Shaykh Muhammad would have been too old to be director of the royal workshop, but certainly would have enjoyed a position of great respect, as its 'artist emeritus'.

Sadiqi Beg, born in 1533, contributed his first known royal commissions to the 1573 *Garshaspnameh*. After the death of Shah Tahmasp, he remained in Qazvin, where he worked on illustrations for Shah Isma°il II's *Shahnameh*. Like so many other court artists, Sadiqi Beg seems to have drifted eastwards to Khurasan after 1577, but upon the accession of Shah °Abbas I he was appointed director of the royal *kitab khaneh* at Qazvin. Sadiqi Beg's early manuscript illustrations and single-page portraits adhere to the established style of Qazvin: figures are tall, slim and elegant, with pursed lips but otherwise generally idealised features. Yet, on his return to the royal workshop, his draughtsmanship gained an unexpected mastery and freedom. Either the more intense exposure to the influence of Shaykh Muhammad or the competition of the younger artist Riza could have caused this development, but the result was a novel technique of drawing in which lines of varying thickness define forms. This method, combined with Shaykh Muhammad's freedom of line and incisive characterisation, laid the foundation

61 Bird study, with false signature of Shah Quli. Safavid, Qazvin, late 16th century. Page 44.3 × 30.7 cm; drawing 10.2 × 15.8 cm. Although this drawing bears the name of Shah Quli, a Persian artist who moved to the Ottoman court at Istanbul in the first half of the 16th century, the loose, wet treatment of line has little connection with the tight, wiry style of that artist.

for the prevailing style of the late sixteenth century. As if liberated by the new, calligraphic approach to drawing, artists of varying levels of skill experimented with the technique and produced many studies in addition to finished works.

Shah ʿAbbas I (r. 1587–1629)

Depleted coffers, Qizilbash conspiracy, Ottomans threatening in the west and Uzbeks looming in the east – this was the state of affairs Shah ʿAbbas I inherited in 1587. With speed and determination the young Shah set about confronting these problems. First, he ordered the execution of an insurgent band of Qizilbash who had tried to murder his chief minister, Murshid Quli Khan. Having gained confidence that he could control his kingdom without ministerial interference, he had Murshid Quli Khan executed. From 1590 onward Shah ʿAbbas consolidated his power within Iran by undercutting powerful Qizilbash and other tribal groups and forming a standing army of Georgians and Circassians loyal only to him. To ensure one peaceful boundary, he signed an unfavourable treaty with the Ottomans in 1590, ceding to them Azarbaijan, Shirvan, Baghdad, Tabriz and parts of other western and northern regions. By 1598 he was ready to take on the Uzbeks, and as a result the Safavids regained Khurasan. Such a victory would have been meaningless had Shah ʿAbbas not also stimulated the economic recovery of Iran by transferring much of the former Qizilbash territory to direct royal control and by encouraging production and trade of textiles and other commodities. From 1603 until his death in 1629 Shah ʿAbbas I managed to regain all the lands his father had

62 'Rubab player', signed by Muhammad Ja[ʿ]far. Safavid, Qazvin, *c*.1590. Painting 13 × 13 cm. Under Shah Tahmasp musicians were all but banished from court for their potentially corrupting influence on the royal princes. Shah Ismaʿil II revived court patronage of musicians and at least one who served him was still active in the time of Shah ʿAbbas I. This portrait is the only known signed work by Muhammad Jaʿfar.

63 OPPOSITE 'Rustam striking the door of Afrasiyab's palace', from a *Shahnameh* of Firdausi. Safavid, Isfahan, *c*.1610. Painting 22.7 × 15.4 cm. Rustam and his Iranian warriors stormed the castle of Afrasiyab, their greatest Turanian enemy, in the dead of night. With one blow Rustam smashed open the gate and then entered the palace, looting and routing the Turanians, though Afrasiyab escaped to fight another day.

lost to the Ottomans, as well as Hormuz, a strategic island in the Persian Gulf, then under Portuguese control.

The symbol of Iran's prosperity and stability under Shah ʿAbbas I was his new capital, Isfahan. A city of gardens, elegant palaces, extensive markets and all manner of public monuments, Isfahan had existed as a cultural centre long before Shah ʿAbbas made it his capital. Yet, under his and his architects' direction the city became not only the seat of government but also a major hub of commercial activity and a microcosm of the new Iranian social order. The administrative move to Isfahan took place gradually during the 1590s and was virtually complete by 1598. While the start of the 'Isfahan style' of painting is usually assigned to the late 1590s, the changes had in fact begun early in the decade. Single-page portraits, both painted and drawn, remained in vogue, but the range of types depicted expanded to include working men, shaykhs and dervishes as well as a variety of courtiers and courtesans. With prosperity emerged a new class of dandies – elegantly clad, seemingly idle youths whose portraits were collected for inclusion in albums or *muraqqaʿs*. The album from which the 'Rubab player' comes was 62

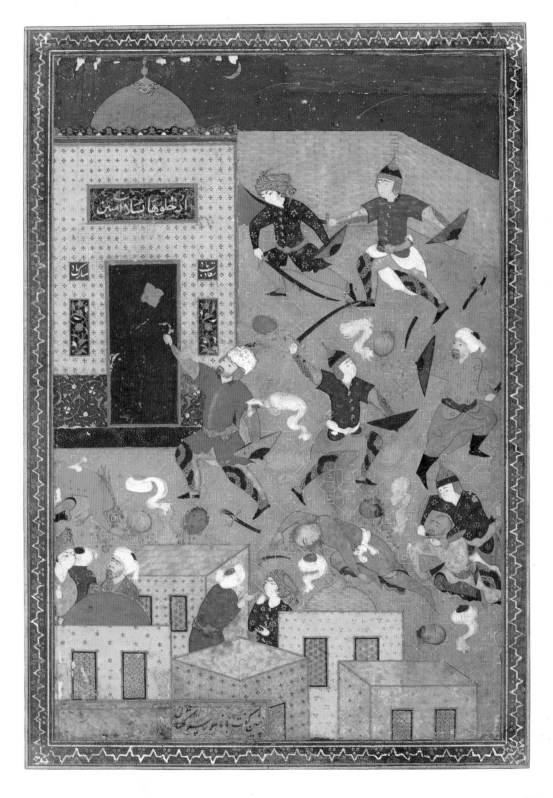

compiled in India and includes Indian and Persian paintings and calligraphy. Released from the strict *kitab khaneh* system, artists who in another era might have been patronised solely by members of the court now sold their works to anyone who could afford them, either locally or abroad.

In the period of economic expansion and artistic revival under Shah ʿAbbas I, one artist towers over all others as the most innovative figure of the age. The son of ʿAli Asghar, an artist at the court of Shah Ismaʿil II, Riza was born about 1565 and joined Shah ʿAbbas's atelier around 1587. Called 'Aqa Riza' and later 'Riza-yi ʿAbbasi' after his master, Riza was once thought to have been two people, not only because of his name change but also on account of the marked stylistic developments during his long career. On a drawing of 1591 Riza noted his debt to Shaykh Muhammad, but by the mid-1590s he had forged a new style, more dynamic and expressive than that of the Qazvin atelier. 'A Man attacked by a 64 bear', which has two inscriptions to Bihzad but which is attributed here to Riza, embodies many of the qualities of Riza's early drawings. First, he has chosen to depict a moment of high drama and has not shied away from showing the man's anxiety, as he furrows his brow and glares at the mauling bear. To heighten the sense of movement, Riza has employed a line of varying thickness, which some scholars believe he, and not Sadiqi Beg, introduced to Persian draughtsmanship. Finally, the drawing contains trademarks of Riza's work in the 1590s, such as the clenched fist, frayed

64 'Man attacked by a bear', attributed to Riza (falsely ascribed to Bihzad). Safavid, Qazvin, *c.*1590–5. 7.7 × 9.3 cm. In the late 16th century artists added the depiction of actual events to their repertoire of portraits and manuscript illustrations. Not until the 1670s were explanatory texts added, but such works with or without texts demonstrate the increasing worldliness of artists on the eve of the 17th century.

turban and sash ends, and the light wash on the rocks. A similar verve characterises most of his paintings of the 1580s and 1590s, including several single-page paintings and four illustrations to an unfinished *Shahnameh* presumably produced for Shah ᶜAbbas I upon his accession. Not only did the young Riza demonstrate remarkable technical skill in rendering textures of cloth and fur, motion, and the personalities of his sitters, but he introduced new subjects to the repertoire of Persian painting, including half-nude recumbent women and meditating shaykhs. As at each stage of his development, his drawings of the 1590s inspired a raft of imitators, many of whose works were bound into albums with his own.

By 1600, when the capital was established at Isfahan, Riza's style had matured and had lost some of its spontaneity. Although he continued to portray youthful courtiers, his more insightful
65 portraits from this period are those of figures such as the 'Scribe'. Often his middle-aged sitters have the glint of intelligence in their eyes and even a slight smile on their lips. By 1600 Riza had retreated somewhat from his earlier, calligraphic line, and increasingly the contours of sitters in formal portraits are closed. About 1603 Riza received the title "ᶜAbbasi', which he appended to his name. However, soon after that date he chose to leave the court atelier and to consort with wrestlers and other low-life types. A remarkable series of drawings of anguished men in the wilderness dates from this period (c.1603–10) and must reflect the artist's troubled state of mind and a reaction against the claustrophobic life at court.

Eventually, perhaps for lack of funds, Riza returned to the court atelier. With the exception of a few works from about 1610 in his earlier style, his *oeuvre* now became more ponderous. Not only did his palette change – half-tones such as rust and purple-brown replaced primary colours – but immobile, heavy-jawed, thick-thighed figures supplanted his earlier nimble, bright-eyed youths.

Although Riza did illustrate manuscripts in the second decade of the seventeenth century, the great majority of his works were single-page portraits. Other artists contributed to illustrated manuscripts in this decade, but most were painting in a style based on Riza's mode of the late 1590s or reviving the late fifteenth-
63 century mode of Bihzad. Such pseudo-Timurid works usually give themselves away by large, floppy mid-Safavid turbans and occasionally extreme poses.

During the 1620s Riza himself looked to the works of his predecessors for inspiration. In addition to a group of drawings after originals by Bihzad, perhaps intended as a tribute to the great and
66 famous master, he painted a portrait after an original by Muhammadi. A young man of far more svelte physique than Riza's other

65 'Scribe', signed by Riza. Safavid, Isfahan, c.1600. Drawing 10 × 7 cm. Persian calligraphers were highly respected by their contemporaries and often combined their skills in penmanship with other serious pursuits such as writing poetry, composing and performing music, or compiling historical treatises.

sitters in the 1620s is seated on a spindly seat typical of the sixteenth century. Only his face, with its almond eyes and heavy brow, and the wispy gold vegetation adhere to seventeenth-century norms.

Riza outlived Shah ʿAbbas I, who died in 1629. His latest works were mostly portraits, except for one illustrated *Khamseh* of Nizami in which many miniatures are the work of his students. In these compositions Riza reduced the number of figures and enlarged their scale, placing them close to the picture plane. His late portraits, from 1630 until his death in 1635, exhibit an abiding interest in character and in novel subject-matter, such as a woman seated in her lover's lap or a European feeding wine to a dog. By the late 1620s the trickle of European visitors to the court at Isfahan had increased to a steady flow, introducing the Iranian public to European styles of art, dress and behaviour, and although Riza

66 'Seated youth', signed by Riza. Safavid, Isfahan, c.1625. Painting 14.1 × 7.7 cm. The inscription on this portrait states that it was made on the order of 'the prosperous, illustrious, most pure and elevated lord', that is, the shah, and that it is based on an original by Muhammadi of Herat.

never attempted to borrow the European artistic techniques of shading or perspective, he seems to have been amused by the appearance and actions of the foreigners. Ironically, for some of Riza's followers European art proved irresistible and its introduction ultimately changed the course of Persian painting.

— 6 —

THE LONG DECLINE

1629–1722

The Late Safavid Shahs

In a sense Shah ʿAbbas I and Riza left similar legacies. The organisation of the state and the territorial boundaries established by Shah ʿAbbas were maintained more or less intact by his successors, in spite of the limited abilities of some of them. Likewise, Riza's followers used his style as a point of departure for their own works. Indeed, Riza set the stylistic parameters for much of seventeenth-century Safavid painting, to which the only alternative was working in the European mode.

Having murdered his son, Shah ʿAbbas I was succeeded by his grandson, Shah Safi I (r. 1629–42). Reared in the harem, Safi was not only addicted to drink and drugs but also had little sense of how to rule. Fortunately, he had an able chief minister who kept the country solvent, so upon his death Iran remained stable. Like Ismaʿil II, Shah Safi was cruel and suspicious, and numerous high officials and Safavid princes were put to the sword. The young were spared, so when Safi died from the effects of alcohol in 1642, his ten-year-old son ʿAbbas was able to succeed him.

On the whole, the reign of Shah ʿAbbas II (1642–66) was peaceful, just and prosperous. He avoided most military embroilments, except for a battle against the Mughals for control of Qandahar, which the Safavids won in 1648, and played a far more active role in the administration of Iran than had Shah Safi. Only on

a personal level did ʿAbbas II demonstrate weakness. He, too, was addicted to wine, drugs and sex, tastes strongly frowned upon by the religious classes of Safavid society, who were, however, powerless to dissuade him and his court from such decadent activities. His proclivities led to his premature death in 1666 at the age of 33.

With the accession of Shah Sulayman (r. 1666–94) the decline of the Safavid dynasty began in earnest. Sulayman's disinclination to busy himself with affairs of state led to the mismanagement of the economy and to corruption and injustice. Luckily he had no military or territorial ambitions save maintaining the status quo, so Iran did not suffer at the hands of its traditional enemies. Nevertheless, the country decayed from within. With a Shah who retreated to the harem for months on end, and a shadow government of scheming eunuchs and concubines, neglect of the social, military and administrative structures was inevitable.

Two main factors influenced Persian artists between 1630 and 1722: the work of Riza and European art. Although only artists' inscriptions and not biographical texts mention Riza's role as a teacher, his late work most certainly served as a model for many court artists under the later Safavid Shahs. One of these, Mir Afzal Tuni, also known as Afzal al-Husayni, produced single-page paintings which show a strong affinity with those of Riza. In fact, Afzal's early unsigned works may have resembled Riza's late paintings so closely that they have been accepted erroneously as the work of the elder master. 'A lady watching a dog drink wine from a 68 bowl' demonstrates how Afzal used Riza's *oeuvre* as a point of departure. Riza had already depicted a dog drinking wine, but in the company of a fully dressed European man, not a seductively posed young woman. Moreover, when depicting a semi-nude female, Riza gives the impression of having just happened upon a sleeping woman, rather than of her having hiked up her dress to expose her fancy undergarments and soft belly. For whatever reason, be it the influence of European painting, the desire to outdo Riza, or the slackening of public moral standards, renderings of nude figures and erotic poses increased throughout the seventeenth century.

While Afzal al-Husayni contributed to a *Shahnameh* manuscript of 1642–51, commissioned by an official for presentation to Shah ʿAbbas II, several of his leading contemporaries were working simultaneously on a *Shahnameh* completed in 1648 for the shrine of Imam Riza at Mashhad. One of these artists, Muhammad Yusuf (Mir Yusuf), also distinguished himself by portraying youths 69 dressed in elegant gold brocades and stylish hats. His figures' long

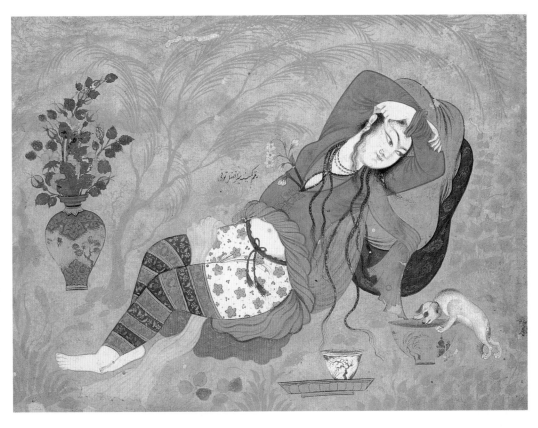

67 OPPOSITE 'Prince being entertained in the countryside', attributed to Muhammad Qasim. Safavid, Isfahan, c.1650. Tinted drawing, 25.2 × 17.4 cm. Before the late 16th century *al fresco* princely entertainments appeared primarily as double-page frontispieces to manuscripts. However, in the hands of Muhammadi and his followers such scenes were removed from the context of manuscripts and produced for inclusion in albums.

68 ABOVE 'A lady watching her dog drink wine from a bowl', signed by Mir Afzal Tuni. Safavid, Isfahan, c.1640. Painting 11.7 × 15.9 cm. In Persian poetry a dominant theme is the yearning for the absent loved one, suggested in this painting by the sitter's dreamy gaze.

69 LEFT 'Young dandy', signed by Mir Yusuf [Muhammad Yusuf] and with effaced owner's seal in lower left corner. Safavid, Isfahan, c.1640–5. Painting 17 × 10.5 cm. The manufacture and trade of sumptuous carpets and textiles, including brocades like those the dandy wears, greatly stimulated the Iranian economy in the 17th century.

70 BELOW LEFT 'Man holding an album', signed by Muhammad Qasim. Safavid, Isfahan, *c.*1650. Drawing 10.9 × 8.1 cm. Drawings of this type were included in albums, not of the oblong type seen here, but either in codex or concertina form.

71 BELOW RIGHT 'Youth in a landscape', signed by Muhammad ʿAli. Safavid, Isfahan, *c.*1650–60. Drawing 11.8 × 6.7 cm. Portraits like this one often contain details, such as the wine-bottle supporting a cup and saucer, which shed light on Safavid daily life.

wispy locks fly in the wind in contrast to their immobile, somewhat comatose-looking faces. Accoutrements such as the European hat and the bottle with a face gazing at the sitter had also appeared in Riza's works of the 1620s and 1630s and continued to be included in paintings by most of his mid-seventeenth-century followers.

Muhammad Qasim, who also worked on the 1648 *Shahnameh*, may have been somewhat younger than Muhammad Yusuf, for he developed a distinctive style that derives from but does not slavishly imitate the work of Riza. A small drawing of a 'Man holding an 70 album' follows the well-known genre of the shaykh or poet in countryside. Yet, the wry upward glance of the man and the dramatic sweep of the hills formed by striated lines and a subtle grey wash have no precedent in the work of Muhammad Qasim's great predecessor. Moreover, while his line shows a similar variation in thickness, it lacks Riza's spontaneity and virtuosity.

A fine tinted drawing of a 'Prince being entertained in the 67 countryside' reveals other traits of Muhammad Qasim's style. Instead of drawing tufts of grass, he has used light green strippling, a technique much in evidence in the 1648 *Shahnameh*. His slightly smiling figures have very round cheeks if young, and are more

square-faced if middle-aged. Although textures and the designs of textiles are not as faithfully rendered as in the painting by Muhammad Yusuf, this meticulous tinted drawing must have been appreciated, as it is stamped with an owner's seal. Finally, it demonstrates that the fashion of combining polychromy and drawing introduced by Muhammadi and continued by Riza still found favour in the mid-seventeenth century.

Muhammad ʿAli, the son of Malik Husayn Isfahani who painted the frontispiece of the 1648 *Shahnameh*, exhibits closer affinities with the style of his contemporary Muhammad Qasim and his forebear Riza than with that of his father. Like Riza and Muhammad Qasim, he favoured such subjects as elegant young men and women or shaykhs in the wilderness. Yet, certain formulae distinguish his style from that of other artists. His youths' sidelocks constantly have wavy undulations on the edge nearest the ear, while the hair along the cheek is straighter and hugs the contour of the face. The nostrils of Muhammad ʿAli's figures are often quite large and flared, in contrast to those of Muhammad Qasim's sitters. In the place of backgrounds with defined horizon lines and naturalistic vegetation, Muhammad ʿAli often places his figures in an undefined space with sprays of floating foliage in the middle and upper ground below billowing, streaky clouds. Generally his sitters appear more serious-minded and less happy than those of Muhammad Qasim, but both artists' work demonstrates the final maturing of ideas introduced in large part by Riza.

Two other artists should be mentioned in connection with the school of Riza. First, Riza's son Muhammad Shafiʿ ʿAbbasi apparently completed works left unfinished at the time of his father's death. Then, during the reign of Shah ʿAbbas II, he was involved in a variety of projects. If authentic, a large drawing of 'Yusuf appearing before Zulaykha' may well be a cartoon for a wall-painting in a palace such as the Chehel Sutun, built at the behest of Shah ʿAbbas II about 1647. Although the actual paintings in the palace are composed of fewer figures, such drawings may have been trial pieces from which vignettes were excerpted. The figure style accords with the prevailing mode of the 1640s, in which shading of faces was in use but did not function to model forms in the European manner.

Through the 1640s and 1650s Muhammad Shafiʿ ʿAbbasi made his name painting exquisite 'portraits' of birds and flowers. Although Riza had painted single birds on rocks in landscape, and a few studies of flowering plants appear in albums which may date from the sixteenth century, paintings of anatomically correct birds, butterflies and bees on or near plants of definable species

71

72 'Bird, flowers and insects', attributed to Shafiᶜ ᶜAbbasi (falsely ascribed to Muhammad Zaman). Safavid, Isfahan, c.1650. Drawing 11.7 × 18.3 cm. The rendering of the bird and tree stump in brown wash is extremely painterly and European in technique, whereas the rest of the drawing is consistent with Shafiᶜ ᶜAbbasi's style. Presumably this composition is a copy of a European original.

represented a new genre in Persian painting. A bird and flower 72 study (falsely dated and attributed to Muhammad Zaman) and an album of drawings, of which some are signed by Muhammad Shafiᶜ, strongly suggest a European source of inspiration. By the mid-seventeenth century trade with Europe was well established and Europeans of all types visited Iran. Presumably to show Iranian textile weavers the types of designs preferred by Europeans, traders from England brought pattern books and perhaps herbals with them to Iran. Thus, while Shafiᶜ's study may have begun as a sketch in brown wash of a bird on a bare branch, the extension of the branch and addition of other plants must derive from a European herbal, in which blossoms of the same plant are shown from different points of view and in different stages of maturity. Whereas Shafiᶜ ᶜAbbasi's bird and flower paintings mask their source of inspiration in their very Persian use of colour and adherence to two-dimensional space, his drawings of the same subject often suggest a borrowed source. A tinted drawing of violets made in 1642 exhibits 74 freedom of line, but still may ultimately reflect a European model. By comparison, another drawing by Shafiᶜ ᶜAbbasi in the same album, dated 1671–2, relies on a European prototype, most likely an etching, for its subject, a floral spray in a European-style jug. 75 Moreover, its technique, in which grey washes and cross-hatching are employed to indicate shading and define three-dimensional

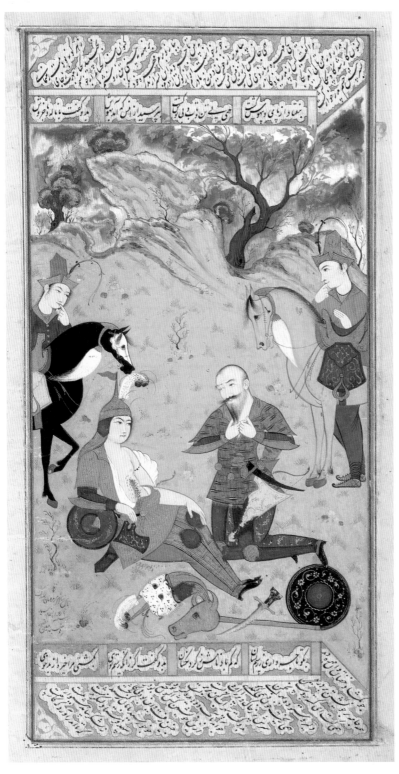

73 'Rustam beside the dying Sohrab', from a *Shahnameh* of Firdausi, signed by Muʿin Musavvir. Safavid, Isfahan, dated 1649. 29.2 × 14.8 cm. Rustam's son, whom he had never seen, marched at the head of an army against Iran. Tricked into believing he was not fighting against Rustam, Sohrab battled on until his father stabbed him. Only then did Rustam take off Sohrab's armour and discover the amulet he had given Sohrab's mother.

 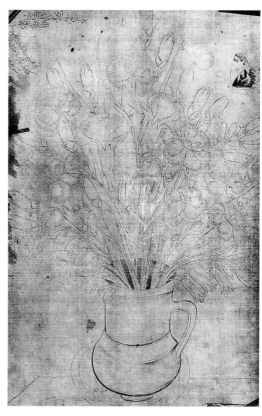

74 ABOVE LEFT 'Violets',
attributed to Shafiᶜ
ᶜAbbasi, with the stamp
seal of Muhammad
Shafiᶜ. Safavid, Isfahan,
dated 5 April 1642.
Drawing 16.9 × 9.6 cm.
Several textiles bear the
name of Shafiᶜ ᶜAbbasi.
Their sensitively
rendered flowers clearly
derive from, but do not
duplicate, his drawings.

75 ABOVE RIGHT 'Flowers
in a jug', signed by
Shafiᶜ ᶜAbbasi. Safavid,
Isfahan, dated 21
January 1672. Page
27.9 × 18 cm. Based on
a European model, this
drawing is on European
paper. See also fig. 4.

form, suggests that Shafiᶜ ᶜAbbasi was looking beyond the mere
subject-matter to try to grasp the mechanics of his European model.

Muᶜin Muzavvir, the most prolific, long-lived and traditional of
Riza's students, produced a body of paintings and drawings that
runs the gamut of genres available to seventeenth-century Persian
artists. Already active in the 1630s, Muᶜin illustrated six known
Shahnamehs between 1630 and 1667, as well as a few histories of
the life of Shah Ismaᶜil I. An illustration to one of the *Shahnamehs*, 73
dated Ramazan 1059/September 1649, is typical of Muᶜin's work. In
an essentially static composition the two protagonists, Rustam and
his dying son Sohrab, have been placed front and centre while their
pages and horses stand in the middle ground behind them. Despite
his mortal wound, Sohrab remains emotionless. Only the turbulent
sky, the restless black horse and the standard gesture of astonish-
ment – a finger held to the lips – suggest that the event portrayed is a
tragic one. While Muᶜin's figural types relate closely to those of
Riza, deviating only slightly in the treatment of eyes and mouths,
his painterly, moody sky characterises his work alone.

In addition to manuscript illustrations, Muᶜin painted and drew
large numbers of single-page works. His drawings are free and

76 'A dragon attacking a man', signed by Mu'in Musavvir. Safavid, Isfahan, dated 20 April 1676. Painting 20.5 × 11.5 cm. Iranian heroes traditionally met dragons in combat, though usually only one at a time, not two as seen here. This painting may allude to a story from the *Khavaran-nameh*, in which Malik attacks seven dragons.

sketchy with a distinctively loose quality of line, more like a brush and watercolour technique than pen and ink. His subjects range from portraits to depictions of actual events, accompanied by inscriptions describing the circumstances in which the works were done. Brilliantly coloured fanciful subjects, such as 'A dragon attacking a man', are also to be found in Muʿin's *oeuvre*, alongside more conventional portraits of men and women. Completed in 1676, 'A dragon attacking a man' gives only the slightest nod to the ever more prevalent external influences of European and Indian art. Aside from some subtle shading on the man's cheek and eyelids, the rendering of his clothes and the dragons maintains a firm two-dimensionality. The subject of dragons attacking heroes is deeply rooted in Persian epic literature; Muʿin would have had no need to borrow such a composition from abroad. In fact, of all Riza's followers Muʿin adhered most closely to a Persian pictorial canon which allowed him the scope to develop his own style and depict a broad range of subjects.

76

Despite a career spanning two-thirds of the seventeenth century and into the eighteenth century, Muʿin Musavvir did not inspire a school of followers as had Riza. In fact, by the 1680s no single style of painting prevailed in Iran. Some artists, of whom the best known is Muhammad Zaman, had adopted far more than the superficial trappings of European painting. In 'A prince on horseback with a

77

77 'A prince on horseback with a courtier and servants', attributed to Muhammad Zaman. Safavid, Isfahan, *c*.1670–85. Painting 20.6 × 14.3 cm. By the last quarter of the 17th century the exchange of people and ideas between Iran and India was long established. Indians such as the figure on the right served at the royal court, and their art began to influence that of Isfahan in the mid-17th century.

courtier and servants', attributed to Muhammad Zaman, working in the 1670s or 1680s, certain passages, especially the winebearer's blue trousers, exhibit the use of highlights and shading to depict folds and suggest the form beneath the cloth. The lightly rouged cheeks and shaded eyelids of the figures also represent an effort to achieve three-dimensionality. Yet the prince's luxurious gold brocade garment and the exquisite turquoise gold, red and white saddle-cloth contrast with the Europeanising modelling by stressing flatness and ornament over form. Muhammad Zaman's *oeuvre* ranges from illustrations added to sixteenth-century royal Persian manuscripts to copies after European prototypes and even botanical paintings.

Lest one forget, not every artist in late seventeenth-century Isfahan painted for wealthy or high-born patrons. Travellers such as the Dutchman Engelbert Kaempfer commissioned artists to paint local animals, people or scenes from daily life, singly or in series. Dr Kaempfer, who spent the year 1684–5 in Isfahan, had an artist fill about forty-five pages of a sketch-book brought from Europe with such paintings. As in European pattern books, two specimens of people or animals are shown on most pages. The artist, Jani son of Bahram, calls himself 'Farangi Saz', that is a painter in the European style. Thus, he invariably includes shading on the ground around figures and makes various attempts at modelling. In one instance he depicts a landscape with European-style leafy trees and sky, but the work itself would hardly be taken for a European portrait. Presumably the motivation for Jani to paint in a European style was commercial and resulted from the demand of foreign travellers for mementos and visual documentation of what they had seen in Iran, a sort of pre-modern photograph or postcard album. By using some European techniques, Jani and his ilk were either following or anticipating the wishes of their patrons for pictures in a more or less familiar mode. For artists such as Muhammad Zaman and his more limited contemporary Shaykh ᶜAbbasi, on the other hand, European paintings and prints presented a point of departure from which to forge a new style of Persian painting. By the 1670s such artists may have felt that the prevailing style of Riza and his school offered no room for innovation or modernity. As in previous centuries artists looked to foreign sources for inspiration. The difference in the seventeenth century was that the source was Europe, not China.

In 1694 Shah Sultan Husayn succeeded his father, Shah Sulayman. A weak ruler like his father, Sultan Husayn allowed the religious class, the *ᶜulama*, to gain great influence in the government, and a period of increasing religious intolerance ensued, with

78 'A man and a woman storyteller', attributed to Jani, from the Kaempfer album. Safavid, Isfahan, 1684–5. Page 20.9 × 29.2 cm. In Iran to this day storytelling is much enjoyed. In teahouses or private residences storytellers would recite tales from Persian epics, often for many hours at a stretch.

Christians, Jews, Sunni Muslims and Sufis all subject to discrimination and punitive measures. By 1720 revolts had broken out along most of Iran's borders. Such instability was an invitation to foreign invaders, and in 1722 the Afghans under Mahmud Ghilzai defeated the Persians in battle near Isfahan and then besieged the capital. Ineffectual as ever, Sultan Husayn did nothing to counter them. After a seven-month siege he abdicated, and the Safavid dynasty came to an end.

Perhaps as a reflection of the lacklustre era of Shah Sultan Husayn, artistic trends that had begun in the reigns of Shah ʿAbbas II and Shah Sulayman continued, but very little that was new was introduced to Safavid painting. Nonetheless, certain paintings capture the mood of the time. 'The distribution of New Year presents by Shah Sultan Husayn', painted by Muhammad ʿAli, son of Muhammad Zaman, and dated 1721, communicates the moribund state of the dynasty as no written account could. The Shah, seated in the midst of a crowd of fawning courtiers, is portrayed

80

expressionless in deep shadow. By contrast, an unknown source of light illuminates the rest of those present. Whereas Muhammad Zaman used European methods of shading on some but not all areas of his paintings, Muhammad ʿAli displays a greater pre-occupation with the play of light over the whole surface. Furthermore, his atmospheric treatment of sky, his modelling of drapery folds and his placing of figures in tiers exhibit a concern with naturalistic effects and three-dimensional forms receding in space. That the artist should have implied a light source from both the left and the right that does not reach the Shah may have been symbolic, but it also demonstrates the tenacity of the indigenous Persian way of seeing and rendering what was seen, in which all that was portrayed was assumed to be visible and equally illuminated.

79 'Famous Sakineh', from the Kaempfer album, signed by Jani Farangi Saz, son of Bahram Farangi Saz. Safavid, Isfahan, 1684–5. Page 21.2 × 29.7 cm. Although the daughter of the Shiite martyr Husayn was named Sakineh, this is more likely a portrait of a young Isfahani woman of that name. The epithet 'famous' suggests that she was a courtesan or a performer.

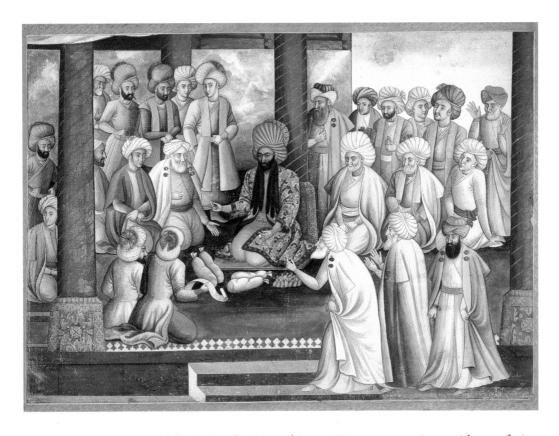

80 'The distribution of New Year presents by Shah Sultan Husayn', signed by Muhammad ʿAli, son of Muhammad Zaman. Safavid, Isfahan, dated 1721. 33.1 × 24.5 cm. At the time of this group portrait the Safavid empire was in a state of collapse.

The 'Distribution of New Year presents' provides a fitting epitaph for both the Safavid dynasty and its style of painting. What had begun in the sixteenth century as a synthesis of prevailing court styles moved in the seventeenth beyond the vocabulary of Timurid painting. Certainly, manuscripts continued to be illustrated and artists continued to emulate Bihzad. Yet major artists such as Riza clearly preferred portraying their contemporaries in modern dress and settings to masking them in the hats and helmets of Bahram Gur and Rustam. With the desire of late seventeenth-century artists to emulate European art, traditional Persian painting fell further out of fashion. The final two centuries of Persian painting before the modern era focus on the somewhat uneasy marriage of European and Iranian styles.

— 7 —

A Taste for Europe

1722–1924

Afghans to Qajars

The abdication of Shah Sultan Husayn ushered in a period of instability and fragmentation to match that following the fall of the Ilkhanids. Although the Afghans controlled parts of Iran, they did not eradicate the whole Safavid house, so in 1722 a Safavid prince proclaimed himself Shah Tahmasp II in Mazandaran. This announcement hardly heralded a renaissance of the Safavid dynasty, but it conveniently enabled Nadir Khan Afshar, an astute general of one of the Qizilbash tribes, to rise quickly behind the Safavid mantle. By 1729 Nadir Khan had overthrown the Afghans and had initiated a series of conquests, the most spectacular of which was his sack of Delhi in 1739. His haul of loot included millions of pounds' worth of jewels and the fabled Peacock Throne of the Mughal emperors. Having had himself declared shah in 1736, Nadir Shah continued his military campaigns into the 1740s and moved the capital to Mashhad. Unfortunately, his management of the non-military affairs of Iran left much to be desired; finally even his own supporters could not bear the double burden of over-taxation and tyranny. In 1747 he was murdered, and the country again slid into chaos.

In the decade after Nadir Shah's death another tribal leader, Karim Khan Zand from Western Persia, attached himself to another puppet Safavid and commenced his political ascent. To

secure his position, he eliminated rivals from the Bakhtiari tribe and another Qizilbash tribe, the Qajars. Unlike Nadir Shah, Karim Khan Zand concentrated on internal government from his new capital at Shiraz, rather than on foreign military adventures. Although he helped heal many of the wounds inflicted on Iran by the Afghans and Nadir Shah, his death in 1779 led to yet another period of instability.

Agha Muhammad, the son of Karim Khan's Qajar rival, emerged as the strongest contender for the Zand spoils. Having been castrated and imprisoned by the Zands, Agha Muhammad avenged himself and the death of his father by murdering the last Zand in the south and the last Afshar ruler in Khurasan. He himself was killed in 1796, but his nephew Fath ʿAli Shah succeeded him and the Qajar dynasty took root in Iran. Unlike his sadistic uncle, Fath ʿAli Shah (r. 1797–1834) presided over a period of relative calm. The main threat to Iran in this period came from a new direction, Europe. Not only did Russia's expansionist policies result in Iran's loss of Georgia and parts of Armenia, but Russia also gained various trade and tariff concessions in Iran to the detriment of the Iranian economy.

Fath ʿAli Shah's grandson and successor, Muhammad Shah, came to the throne in 1834 and ruled until 1848. Although he attempted to liberalise the country, he, too, was manipulated by Russian ambitions and British regional aims connected with maintaining primacy in the Persian Gulf and control in India. The Russian-British rivalry escalated during the long reign of Nasir al-Din Shah (1848–96), taking the form of economic penetration and cultural influence. The Shah himself travelled to Europe in 1873 and on two later occasions, noting with fascination all manner of technological innovations, not to mention the exotic tastes and *mores* of the Europeans. Although he realised that the concessions granted to Great Britain and Russia did not equally benefit Iran, Nasir al-Din Shah nonetheless welcomed the introduction of European ideas and commodities. However, for xenophobic as well as simple economic reasons, resentment of the flood of European goods and European opportunists into Iran grew among the Shiite clergy and urban merchants. Nasir al-Din's spendthrift successor, Muzaffar al-Din Shah (r. 1896–1907), only aggravated the situation and this resulted in the birth of a constitutional movement. A constitution was ratified in 1906, allowing for the election of a National Assembly. While the Qajar dynasty was to last for another eighteen years, by 1906 Iran and its art had joined the modern world. Certainly many time-honoured traditions continued, and the fact that there was both impetus towards and

resistance to change and integration with the rest of the world led to the dialogue between internationalism and isolationism that continue in Iran to this day.

The study of eighteenth-century Persian painting – and by implication the sources of nineteenth-century painting – has been hampered by the inaccessibility of much of the best material, which is held in Iranian collections. Nonetheless, Persian scholars have demonstrated a continuity from the late Safavid period to the Qajar style. First, the Europeanising tendency which proliferated increasingly toward the end of the seventeenth century was maintained and developed by the sons and grandsons of the originators of the

80 style, such as Muhammad ʿAli, son of Muhammad Zaman. Moreover, genres such as oil painting, introduced in the seventeenth century, and the decoration of lacquer boxes and bookbindings remained current in the eighteenth century, even if they were produced in smaller numbers than in the nineteenth. Illustrated

83 historical manuscripts and single-page portraits were also produced for a range of patrons, in a style consistent with that of Muhammad ʿAli and his contemporaries. While the excessive use of shading sometimes endows these works with a dusky quality, they do display an improved understanding of the play of light (coming from a single source) on three-dimensional forms. European motifs and compositions remained in favour through the eighteenth century, and Nadir Shah's looted Indian manuscripts – he donated some 400 to the shrine of Imam Riza in Mashhad – may also have exerted an influence on Persian painters. In sum, most of the ingredients of the Qajar style were available in the eighteenth century, but it took the stability of three long reigns, those of Fath ʿAli Shah, Muhammad Shah and Nasir al-Din Shah, to stimulate the last efflorescence of Persian painting.

Many oil paintings have survived from the period of Fath ʿAli Shah and later. Often they are shaped like an arch in order to fit in a space of the same shape on a wall. While the innumerable depictions of dancers and other revellers were most likely intended for coffee houses and perhaps private dwellings, portraits of princes and historical scenes would have adorned the walls of private

81 palaces. The artist of 'A Qajar prince and his attendant' has faithfully observed the conventions of early nineteenth-century Qajar painting. The loosely rendered mountains and leafy tree in the far distance and undefined middle ground suggest spatial recession. The shading on the figures' faces and hands shows an awareness of modelling. However, the painting is ultimately dominated by passages of flat, brilliant colour and the bands of ornament formed by the diamond, pearl, emerald and ruby belt,

81 'A Qajar prince and his attendant'. Qajar, Tehran, *c*.1820. Oil on canvas, 183 × 91.5 cm. With his jewelled dagger, medal and ornaments the young man in red is most likely a Qajar prince, one of the fifty sons of Fath ʿAli Shah. This may be one of a series of portraits of notable personages designed to fit into arches in the *divan* or public room of a house or palace.

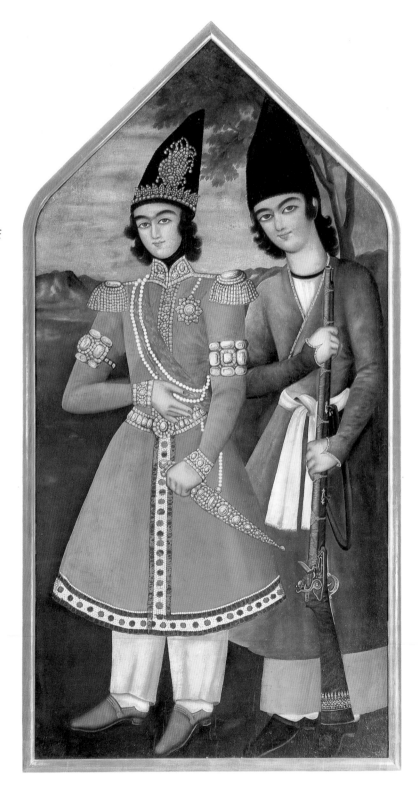

82 'Bird and flowers'. Qajar, mid-19th century. 11 × 16 cm. Although birds and flowers proliferated on lacquerware, book-bindings and painted ceilings in Qajar Iran, they were less often the subject of single-page paintings. Placed at the very beginning of the album, this page functions almost as a frontispiece or doublure (inner side) of the binding.

bracelets and trimmings on the prince's coat. Attractive though such portraits are, the static frontality of the figures lends little insight into their character.

As one would expect, drawings of the same period provided artists with a greater opportunity for spontaneity and originality. 84 The wash drawing of a 'Dog attacking a wolf which has seized a lamb' may refer to a known event, but it is also a vehicle for portraying animals in action and showing a range of their emotions. Another, more formal approach to nature enjoyed great popularity 82 throughout the Qajar period, the bird and flower (*gul o bulbul*)

83 RIGHT 'A young man'. Isfahan?, mid-18th century. Drawing 10.7 × 7.3 cm. This small portrait, mounted in an album, depicts a young man in a tall hat with three visible points, typical of the 18th century. Coats with narrow waists and fur collars and cuffs were in vogue from the mid-17th until the 19th century.

84 BELOW 'Dog attacking a wolf which has seized a lamb'. Qajar, mid-19th century. Drawing 18.4 × 12 cm. With its minimal setting this drawing gives the impression of being a depiction of an actual event, seen by or reported to the artist.

picture. The descendants of Shafic cAbbasi's bird and flower scenes by way of the works of the eighteenth-century artist Muhammad Baqir, such compositions were created for inclusion in albums and also used extensively on lacquer bookbindings, mirrors and boxes.

With the introduction of printing and large-scale paintings, some of the finest Qajar miniature artists turned their hand to lacquer objects. One such piece, signed 'Ya Shah-i Najaf' and dated 1845–6, demonstrates a typical Qajar combination of European busts and vignettes from Christian iconography. The artist Najaf was not only the pre-eminent lacquer painter of his day, but also the scion of a family of artists who dominated the medium for much of the second half of the nineteenth century.

Nasir al-Din Shah was highly enthusiastic about all things European, including the visual arts and photography. He established a technical college in Tehran, the Qajar capital, and brought instructors from Europe to teach photography, among other things. He was a keen photographer himself, and not only photographed members of his family but also made self-portraits. The impact of photography on Qajar painted portraits cannot be underestimated. Portrayed by Khanezad Ismacil in 1853, Nasir al-Din Shah wears the same coat as in a photograph from the same period. As decorative as the carpet beneath him appears, it, too, must have been precisely rendered by the artist. Such verisimilitude is matched by the direct gaze of the Shah, a lack of modesty that would have been unthinkable before the Qajar period. Although one still cannot read much into the Shah's character, he is a recognisable individual, not just an idealised type. Moreover, details of his pose, such as one foot resting on the other and the fingers pressed together, may well represent mannerisms peculiar to him. The deep red velvet settee, bright yellow wall and opaque windows reflect the Shah's mid-nineteenth-century Europeanising taste, but they also bespeak a close, airless world and by extension a land being strangled by the very forces to which it and its leader were most irresistibly drawn.

To late twentieth-century Western eyes, Qajar painting often appears odd and sometimes downright funny. Still-lifes, portraits, historical events and Christian scenes sometimes share the surfaces of a single penbox or mirror-case. Shading and attempts at perspective appear in works with stubbornly two-dimensional passages. Yet, from the point of view of the artists who produced them, such variety no doubt indicated their own virtuosity and must have appealed to their patrons. One could not expect an aesthetic that began long before the first illustrated manuscript to disappear entirely in one century. Thus, as they had done so often in

85 Penbox, signed by Najaf cAli. Qajar, dated 1845–6. Lacquer on papier mâché, L. 22.1 cm.

86 'Nasir al-Din Shah', signed by Khanezad Isma'il. Qajar, dated 1853–4. Painting 33 × 21.1 cm. The artist, also known as Muhammad Isma'il, was a celebrated portraitist and lacquer painter in the mid-19th century. This portrait was apparently very influential, as it was copied at least three times in the later 1850s.

previous eras, the Persians adopted the aspects of the foreign style that appealed to them and grafted them onto their own tradition. In the hands of the most gifted artists of the day, the combination of old and new bore fruit in the form of a distinctive but wholly Persian style of painting.

FURTHER READING

Aḥmad, Qāḍī (Qazi), *Calligraphers and Painters: A Treatise by Qāḍī Aḥmad, Son of Mīr Munshī*, trans. V. Minorsky, *Freer Gallery of Art Occasional Papers*, vol. 3, no. 2, Washington, DC, 1959

Binyon, L., Wilkinson, J.V.S. and Gray, B., *Persian Miniature Painting*, London, 1933, reprinted New York, 1971

Brend, B., *Islamic Art*, London, 1991

Canby, S.R. (ed.), *Persian Masters: Five Centuries of Painting*, Bombay, 1990

Dickson, M.B. and Welch, S.C., *The Houghton Shahnameh*, 2 vols, Cambridge (Mass.), 1981

Grabar, O. and Blair, S., *Epic Images and Contemporary History: The Illustrations of the Great Mongol Shahnama*, Chicago, 1980

Gray. B. (ed.), *The Arts of the Book in Central Asia*, Paris and London, 1979

Lentz, T. and Lowry, G., *Timur and the Princely Vision: Persian Art and Culture in the Fifteenth Century*, Los Angeles and Washington, DC, 1989

Robinson, B.W., *A Descriptive Catalogue of the Persian Paintings in the Bodleian Library*, Oxford, 1958

Robinson, B.W., *Persian Miniature Painting from Collections in the British Isles*, London, 1967

Robinson, B.W. (ed.), *Islamic Painting and the Arts of the Book*, London, 1976

Robinson, B.W., *Jean Pozzi: L'Orient d'un Collectionneur*, Geneva, 1992

Rogers, J.M., Cagman, F. and Tanindi, Z., *The Topkapi Saray Museum: The Albums and Illustrated Manuscripts*, London, 1986

Simpson, M.S., *Arab and Persian Painting in the Fogg Art Museum*, Cambridge (Mass.), 1980

Stchoukine, I., *Les Miniatures des Manuscrits Timurides*, Paris, 1954

Stchoukine, I., *Les Peintures des Manuscrits Safavis de 1502 à 1581*, Paris, 1959

Stchoukine, I., *Les Peintures des Manuscrits de Shāh ʿAbbās à la Fin des Safavis*, Paris, 1964

Thackston, W.M., *A Century of Princes: Sources on Timurid History and Art*, Cambridge (Mass.), 1989

Titley, N., *Persian Miniature Painting*, London, 1983

Welch, A., *Artists for the Shah: Late Sixteenth-Century Painting at the Imperial Court of Iran*, New Haven, 1976

Welch, S.C., *A King's Book of Kings: The Shah-Nameh of Shah Tahmasp*, New York, 1972

Welch, S.C., *Persian Paintings: Five Royal Safavid Manuscripts of the Sixteenth Century*, New York, 1976

Sources of Illustrations

INDEX

Numbers in **bold** refer to illustrations